The Psychology of an Art Writer

T0040220

David Zwirner Books

ekphrasis

The Psychology of an Art Writer
Vernon Lee

Translated by Jeff Nagy

Contents

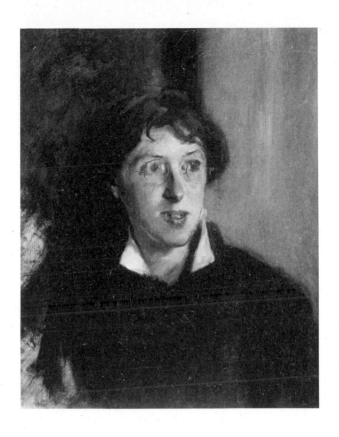

John Singer Sargent, *Vernon Lee*, 1881
Oil on canvas, 21⅛ × 17 inches | 53.7 × 43.2 cm. Courtesy Tate, London, 2017

Editor's Note

Vernon Lee wrote the essay that makes up the first part of this book, "Psychology of an Art Writer (Personal Observation)," in French as "Psychologie d'un écrivain sur l'art (observation personelle)." As an American publisher, we have chosen to translate the piece into American English. For the second part of this book, made up of excerpts from Lee's longer, English-language "Gallery Diaries," we have striven to respect Lee's original text as far as possible by maintaining British spelling, syntax, and conventions. However, in certain rare cases we have made slight modifications to grammar and punctuation to reflect contemporary usage.

We have also converted footnotes to endnotes in the interest of greater readability. Almost all notes are Lee's own, though we have occasionally added additional bibliographical information so that readers can further explore Lee's sources.

The Real Self

Dylan Kenny

There is in one's own jottings something curiously unique; and after a lifetime spent in working on my own notes, I still sometimes catch myself feeling as if such manipulation of them came between me and my real self.[1]

Vernon Lee was the nom de plume of Violet Paget (1856–1935), a writer of astonishing range and audacity whose published works include historical studies of art and music, dense treatises on aesthetic psychology, acclaimed travel essays, meditations on gardens, pacifist and feminist pamphlets, and supernatural tales. Her versatility is difficult for us to comprehend, which is one reason why she is not now as widely read as she deserves. Already in her later years she presented the avatar of a bygone intellectual moment. In a 1920 review of her political-philosophical allegory *Satan, the Waster*, Bernard Shaw (in fact also born in 1856) saluted her as a figure of "the old guard of Victorian cosmopolitan intellectualism."[2]

Lee's cosmopolitanism was not restricted to her intellect. Born to English parents in France, she had a nomadic childhood, living all over France, Germany, and Switzerland before finally settling in a villa in Florence, which would remain her home for the rest of her life. She drew intellectual collaborators and adversaries from across Europe, and though she commanded widespread respect, this did not always imply fondness. Henry James warned his brother William that Lee was "as dangerous and uncanny as she is intelligent, which is saying a great deal."[3] Perhaps even to her contemporaries Lee remained too various to grasp.

This volume can only offer one of Lee's aspects: that of the aesthetic theorist. Even of this Lee it will provide only a glimpse, since her thought on art and beauty seeps through her literary criticism, her ghost stories, her historical meditations. Moreover, the texts reproduced here, "Psychology of an Art Writer (Personal Observation)" and excerpts from the "Gallery Diaries," aim at but do not complete a systematic account of aesthetic response. They are less abstract than many of her other contributions to aesthetic psychology. Nevertheless, in these personal, quite candid reflections on her own experiences of art, we can watch her theory brush up against the world and take shape.

Lee had already been studying art and aesthetics for decades by the time she wrote "Psychology of an Art Writer" and took the notes that became the "Gallery Diaries." She had baptized herself as a "student of aesthetics" in her 1881 volume *Belcaro*,[4] by which she meant that she was turning her attention from art in its historical context to art's effects on individual experience. It was also in 1881 that she first met Walter Pater, who had laid out a program for such study in the opening pages of his 1873 *Studies in the History of the Renaissance*: "to define beauty, not in the most abstract but in the most concrete terms possible, to find, not its universal formula, but the formula which expresses most adequately this or that special manifestation of it, is the aim of the true student of aesthetics."[5] Lee openly acknowledged Pater's influence on her efforts to approach the beautiful through the following decades.

Her 1884 volume *Euphorion* was dedicated to him, and her 1896 *Renaissance Studies and Fancies* concluded with a "Valedictory" eulogizing the recently deceased master. There, Lee defended Pater against the imputations of decadence associated with the slogan "art for art's sake." His aestheticism was not irresponsible hedonism, she insisted, but a recognition of the power of art to harmonize the self with itself and with the world. Reflecting on this conviction years later, Lee conceded that it was vulnerable to the charge of mysticism or even childishness: "But is anything worth attaining ever attained, whether knowledge or love, without some such brief and hushed moments of expectant childishness?"[6]

As Lee's farewell to Pater, the 1896 "Valedictory" also marked the conclusion of one phase in her study of aesthetics, for she was already hard at work on the investigations of aesthetic psychology that generated "Psychology of an Art Writer" and the "Gallery Diaries." From her earlier work and her readings of Pater she retained the conviction that the study of aesthetics had to begin with individual experience. But her sense of what constituted aesthetic experience had begun to expand, and in particular, she began to focus on the effects of art on the body of the beholder. In this new inquiry, she was no longer following Pater, but was a student of her lover, the artist and writer Clementina "Kit" Anstruther-Thomson.

Lee and Kit were practically inseparable companions from 1887 to 1898; Lee's biographer Vineta Colby has called their relationship a marriage "in all but a literal

sense."[7] In 1924, Lee wrote that watching Kit approach art, innocent of erudition but finely attuned to her own bodily and affective responses, convinced her that "for ten or more years I had written about art without having really seen it."[8] Lee was impressed by Kit's description of the subtle effects of a work of art on her body: quick breaths, sensations of movement, muscular tensions. These effects had nothing to do with the subjects depicted by the artwork, but were entirely matters of form: lines, curves, rhythm, movement. Lee and Kit began to wonder if the interaction of form and the body was not in fact the primary moment of aesthetic experience, anterior to any mental impression of beauty. The experience of pleasure would be the effect, not the cause, of such bodily sensations. They found a parallel idea in the new theory of emotion developed independently by William James and Carl Lange, who proposed that what we commonly refer to as the physiological expressions of emotions are in fact identical with emotions. Fear does not cause goose bumps and quicken the heart; it simply *is* those symptoms. Following the same logic, beauty would not be the cause of bodily responses; rather, the physiological response would constitute beauty.

Here, Lee always conceded, she was following the testimony of Kit, whose body seemed so much more sensitive to artworks than her own, and who was so much more adept at registering her physiological responses. Kit was "skilled from childhood in every kind of bodily activity and possessing every kind of dexterity of hand";

in contrast, Lee found in herself "neither facility nor training in bodily activities … conscious life concentrated, so to speak, on the eye and the literary faculties."[9] Lee would later recall how Kit's physical energy totally surpassed her own, how Kit had nursed her when she was ill, and had challenged her to stretch the limits of her body as she grew exhausted by continual gallery wandering. In turn, Lee pushed Kit's mind, encouraging her to work toward a publication of the aesthetic theory they were developing together. In the end, it was Kit who could not bear the intensity of their collaboration. Just before their joint essay "Beauty and Ugliness" appeared in 1897, she suffered a nervous breakdown. Soon afterward, Kit and Lee separated, although they remained dear to one another, and Lee became Kit's literary executor upon her death in 1921.

Lee always gave "Beauty and Ugliness" pride of place in her aesthetic theory, even as she came to correct and refine it over the years. When she published a volume of collected writings on aesthetics in 1912, under the title *Beauty and Ugliness*, she reprinted the essay in its entirety at the center of the book. She added a few footnotes, but did not change the body of the essay, except by bracketing certain passages where she and Kit now diverged. Lee had come to believe that the bodily responses she had found so compelling in Kit were probably secondary expressions of an essentially mental phenomenon: "empathy," or, as it was named in German aesthetic theory, *Einfühlung*.

When Lee and Kit composed "Beauty and Ugliness," they were unaware of the psychological aesthetics being developed in Germany by Theodor Lipps and Karl Groos, but their work showed striking parallels. Lipps's theory of *Einfühlung* (literally "feeling-into") proposed that in the act of perception, we project ourselves mentally into what we perceive. This would explain, for example, why we might say that a line has "rhythm": because our eyes follow it with a certain movement, and this movement activates memories of former movements, we attribute motion to the line. One point of contention in the debate over *Einfühlung* was just how much it was a physical process. Lipps maintained that it was purely mental, and saw in "Beauty and Ugliness" too much emphasis on the body, evidence of a general "cult of bodily sensations" in psychology.[10] Karl Groos, on the other hand, believed that empathetic projection was always accompanied by minute physical imitation of the form perceived. Later on, Lee came to vaguely associate Kit's views with Groos, and her own with Lipps. But she went farther than either of the psychologists wished in making empathy the foundation of our judgments of beauty and ugliness, and refusing to suspend the question of why we like some artworks and not others.

After "Beauty and Ugliness," Lee came to see herself as a fellow traveler of these aesthetic psychologists, but always maintained distance. From her villa in Florence, she kept up with their journals, and occasionally published in them. She submitted a questionnaire on "the

motor element in visual aesthetic perception" to the Fourth International Congress of Psychology in Paris in 1900.[11] The texts presented in our volume originally appeared in the *Revue philosophique*, a leading journal of psychology. Oswald Külpe, the Würzburg experimental psychologist, respectfully noted in a 1907 literature review that the "Gallery Diaries," although methodologically suspect, showed some promise.[12] Külpe and his students were trying to address the rudiments of aesthetic response in highly controlled settings. A famous Külpe experiment involved flashing projections of ancient Greek artifacts for a few seconds before a spectator to see if they sensed anything like Lipps's *Einfühlung*. (The results, such as they were, were negative.) Nothing could be further from Lee's long walks, sometimes alone, sometimes with friends, through the great museums and cathedrals of Italy, already packed with guided tours.

Lee had in fact visited Külpe's laboratory in 1911, and was greatly impressed: "I have come away with the conviction not only that theirs is the future way of studying aesthetics, but also that is the way in which, alas! I can never hope to study them. My aesthetics will always be those of the gallery and the studio, not of the laboratory."[13] She and Kit, she wrote, were the rear guard of psychological aesthetics, like the dabbling eighteenth-century antiquarians superseded by modern archaeology. What she framed as her untimeliness may be precisely what keeps her interesting. The "Gallery Diaries," relatively free of the technical vocabulary of the psychological aesthetics of

her time, provide one of its most compelling documents today. Lee was fascinated by the foundations of aesthetic experience, but she refused to reduce it to those foundations. Artworks work on our bodies. Lee saw that any aesthetic theory had to give an account of the interface between the body and the world, but that such an account could not exhaust the experience of art.

It certainly could not fully explain why we might be moved by one artwork and not another, or, even stranger, why we might be moved one day and untouched the next. Because Lee never bracketed these questions, her aesthetic theory approaches a theory of the self. Who has not had days of dullness? Who has not tried to force themselves to be moved, to be interested, wandering through a museum? For Lee, the experience of boredom, of just not feeling it, was as much a problem for aesthetic theory as the experience of rapturous engagement. Blockages like weather, crowds, and heartache were not extraneous variables but essential elements of aesthetic experience. Lee never cast out evidence in advance for the mysterious workings of art. The object of her investigations was the self. The stage of these investigations was the world, where tourists intrude, friends die, days are sunny, you have a tune in your head. All of this is possible evidence for what art does to us.

Lee never intended for her own self-analysis to be the sole foundation for aesthetic theory. She was relentlessly introspective, but also committed to collaboration. "Psychology of an Art Writer" and the "Gallery Diaries" mod-

eled a method for fellow "psychological workers,"[14] as a kind of manual of attention. Lee's wager in these texts is that aesthetic experience is emphatically individual but not atomized beyond communication, and it is only through such communication that we might refine our understanding of art and its effects. By sketching a capacious picture of the experience of art, they stand as a challenge to the more anemic versions of laboratory aesthetics. The optimism of Lee's position is that aesthetic theory can be synced up with aesthetic experience. Such a theory, she says, must be social as well as rooted in the body. It must account for boredom as well as rapture. It must take up day-to-day changes as well as long-term fixations. A rich vision of art is a rich vision of the self. There remains much in Lee's vision of art to guide today's psychological workers.

A Note on the Texts

"Psychology of an Art Writer" and an early version of the "Gallery Diaries" were first published in French in the psychological journal *Revue philosophique*, as, respectively, "Psychologie d'un écrivain sur l'art (observation personelle)" (1903) and "Essais d'esthétique empirique: l'individu devant l'oeuvre d'art" (1905). The "Gallery Diaries" were subsequently republished in the 1912 volume *Beauty and Ugliness*, this time in the original English, and with slight modifications in text and commentary. The present text is excerpted from this 1912 edition.

Further Reading

Those who wish to get better acquainted with Vernon Lee should turn first to her works. You will see traces of the Lee presented in this volume, but much else besides, in her art criticism, her ghost stories, and her travel writings (much praised by Edith Wharton, among others). Most of Lee's voluminous oeuvre is now out of print, but happily a great deal of it is available online.

The standard bibliography of Lee's works is Phyllis F. Mannocchi, "'Vernon Lee': A Reintroduction and Primary Bibliography," *English Literature in Transition* 26, no. 4 (1983): pp. 231–267. Scholarship on Vernon Lee has grown and accelerated over the last few decades; a good introduction to the literature is the 2006 volume *Vernon Lee: Decadence, Ethics, Aesthetics*, edited by Catherine Maxwell and Patricia Pulham. Her life story has been well served by Peter Gunn and the literary biography of Vineta Colby. On her aesthetic thought in its intellectual context, and the "Gallery Diaries" in particular, I recommend Whitney Davis, *Queer Beauty*, and Benjamin Morgan, *The Outward Mind: Materialist Aesthetics in Victorian Science and Literature*.

1 Vernon Lee, introduction to *Art & Man*, by Clementina Anstruther-Thomson (London: John Lane, 1924), p. 63.
2 George Bernard Shaw, "A Political Contrast," *The Nation* (London), September 18, 1920, p. 758.
3 Cited in Peter Gunn, *Vernon Lee: Violet Paget, 1856–1935* (London: Oxford University Press, 1964), p. 2.
4 Vernon Lee, *Belcaro: Being Essays on Sundry Aesthetical Questions* (London: W. Satchel & Co., 1881), p. 5.

5 Walter Pater, *The Renaissance: Studies in Art and Poetry; The 1893 Text*, ed. Donald L. Hill (Berkeley: University of California Press, 1980), p. xix. (Only the first edition, in 1873, appeared under the title *Studies in the History of the Renaissance*; subsequent editions were published as *The Renaissance: Studies in Art and Poetry*.)

6 Lee, introduction to *Art & Man*, p. 33.

7 Vineta Colby, *Vernon Lee: A Literary Biography* (Charlottesville: University of Virginia Press, 2003), p. 170.

8 Lee, introduction to *Art & Man*, p. 29.

9 Vernon Lee and Clementina Anstruther-Thomson, *Beauty and Ugliness* (London: John Lane, 1912), p. 136.

10 Theodor Lipps, "Dritter ästhetischer Litteraturbericht," *Archiv für systematische Philosophie und Soziologie* 6 (1900): p. 385.

11 In fact she submitted the questionnaire as a collaboration between Kit and herself, but only Lee is listed among the participants in the conference. "Questionnaire sur le rôle de l'élément moteur dans la perception esthétique visuelle," in *Quatrième Congrès International de Psychologie: Compte Rendu des Séances et Texte des Mémoires*, ed. P. Janet (Paris: Alcan, 1901), pp. 474–477.

12 Oswald Külpe, "Der gegenwärtige Stand der experimentellen Ästhetik," *Bericht über den 11. Kongreß für experimentelle Psychologie* (Leipzig: Verlag von Johann Ambrosius Barth, 1907), p. 18.

13 Lee and Anstruther-Thomson, *Beauty and Ugliness*, p. viii.

14 Lee and Anstruther-Thomson, *Beauty and Ugliness*, p. 252.

Psychology of an Art Writer (Personal Observation)

Vernon Lee

I first set myself the task of investigating what I'll call my aesthetic record mostly in order to better question others, and even to serve as an example to them. But as my self-examination began to bear fruit, in the form of observations that sometimes surprised and unsettled me, I found myself in possession of a collection of facts that bridges the gap between the subjective study of aesthetics and psychology in general. The reader will see that this fragmentary, autobiographical confession serves as evidence—purely individual and empirical evidence— for the following issues:

1. The existence of an abstract affective memory, through which an aesthetic feeling can be transferred from one set of sensations to another, and thanks to which it can enter a standby state, ready to express itself in response to sensations that wouldn't have summoned it up spontaneously, for lack of specialized training.

2. The connections between the set of distinct factors that contribute to aesthetic pleasure: the direct perception of a form as such; its interpretation in terms of what it's meant to represent; emotional qualities inherent in perceiving the form or tied to it by association; and, finally, the individual's intellectual and imaginative activity.

3. The connections between an individual's aesthetic experiences and her experience of pleasure in general. This includes issues related to the affective "tone" of

life, to the affective partiality of memory, and to a larger or smaller need for novelty, for violent sensations—for everything the German aestheticians call *intensive Reize*.

4. The role of aesthetic phenomena in the life of the individual. Do beauty and ugliness form an ever present binary in the life of feeling? Does *beauty* correspond to a permanent and continuous internal drive, or does it constitute an exceptional psychic state? In other words, do art, poetry, and natural beauty induce intense but fleeting states of mind, acute pleasures one step removed from ecstasy? Or do they rather give rise to diffuse and enduring moods, for the most part barely or not at all distinguishable from what one might call not *pleasure* but *satisfaction*?

Turning over my memories from childhood and adolescence, I can tell right away that the words *Beauty* and *Beautiful* have played a critical role in my life, particularly from the age of twelve, when my family moved to Rome. It was then that I found myself, for the first time, face-to-face with works of art and involved in discussions where art came constantly into play. I devoted myself to reading books on art, and I began to have theories on the subject. More or less confusedly, the idea that I should become interested in aesthetics merged with my literary ambitions. By the time I was sixteen and fate sent me, as a Latin tutor, a German archaeologist who has since made a name for himself, I had already read Blanc's *Grammar*

of Painting and Engraving, Winckelmann's *History*, and Lessing's *Laocoön*, and I was naturally interested in my teacher's conversations and in the books I convinced him to lend me. Here, I want to return to the phrase I began with, this time with a different emphasis: the *words* Beauty and Beautiful have played a critical role in my life. I want to make clear that, at least *in relation to visual art*, the pleasure and meaning I attached to these terms had very little to do with objects' aesthetic features as I now perceive them. Back then, I paid little attention to such qualities, and I can hardly remember having had my own spontaneous, intuitive preferences for artworks. Instead, the opinions of others played the principle role in the formation of my aesthetic taste (including therein my occasional adoption of a willfully contrary attitude). Brought up in the company of a child who has become a famous painter, I deliberately adopted his interests, and latched on even more strongly to the preferences that my young friend's mother frequently expressed in our presence.

A single fact will serve to demonstrate just how much my taste in sculpture and painting was purely the result of imitation. Consider the following paradox, which persisted in my preferences until my sixteenth year, when I fell under the sway of my archaeologist Latin tutor.

In sculpture, I declared myself strongly in favor of beautiful forms, and for a relative lack of expression and dramatic content. On the other hand, in painting, I spurned the Renaissance masters (Raphael, Titian, Michelangelo,

et cetera), insisting that there was nothing to be found in their work but "technical" qualities. I much preferred the Bolognese painters (Guido Reni, Guercino, and the Carracci brothers), on account of the "soul" they put into their canvases. This incoherent position was due to a simple constellation of facts. On the one hand, in the conversations I'd heard and in Hawthorne's novel *The Marble Faun*, which the tourists of the time used as an aesthetic compass, *antiquity*—the piles of statues both good and bad that stuff the museums of Rome—was on the same agenda with Canova, Thorwaldsen, and the rest of the living imitators of classical sculpture. But, in terms of painting, the Bolognese school was much more strongly represented in Rome than any other, and the literature of the era was still imbued with the sentimental preferences of the eighteenth century. Stendhal, Shelley, and nearly all the writers that were read in Rome in those days had spoken highly of Guido Reni and Guercino. Today the only good one can say about it is that those writers brought out the paintings' sentimental side. I believe that I was completely in thrall to the opinions I heard around me, which seemed to have a certain authority in my eyes. Another circumstance occurs to me here, one that makes me think that my "preferences" in visual art had nothing spontaneous or authentic about them. I mean the fact that after the first winter I spent in Rome with the S——family, I wasn't taken on trips to the museums anymore, and so my ideas about art were drawn from the copies I saw displayed in shopwindows,

and from a collection of photographs I'd assembled, most of them small and of poor quality. It was only after I'd turned sixteen that I came to any serious acquaintance with the galleries of Rome, under the influence of my Latin tutor and the books he lent me.

So I can say with near certainty that in those early years I hardly took any pleasure at all from the beauty of paintings or drawings. But I did experience frequent and vivid pleasure from the *idea* of that beauty, and that's the distinction I have to make perfectly clear. Flipping through my wretched collection of photographs, glancing at the copies set up in shopwindows, and above all thinking back on the vague image of a canvas, often little more than a nebulous profile—when I spoke of and thought about art, I certainly felt the same emotion, or to put it better, I found the same affective tone that I had much later under the absolutely real and direct influence of plastic beauty. How can I explain the presence of what one might call a *borrowed* feeling? And how could I have come by it without personal experience? There's no need to resort to the hypothesis that I was imitating feelings whose existence had been asserted by others—a hypothesis that would itself require an explanation. This feeling, which I automatically ascribed to the visual arts in what was almost a gesture of fealty, arose in me, spontaneous and personalized, in other categories of experience.

For instance, I was well acquainted with the feeling connected to the words *Beautiful* and *Beauty* in the context of music. I realize that in my childhood, as a rather

docile soul, I adopted the preferences of anyone who spoke or wrote with authority, but I'm certain that, at least where music was concerned, these preferences were combined with my own predispositions. Music pierced me, caught me in its grasp: in this corner of the arts I experienced real pleasure connected to an actual exercise of attention. The persistence of my musical tastes through time are a confirmation of this fact. While my preferences for canvases, statues, and architecture have often changed, both overall and piece by piece, my musical preferences have stayed what they already were at twelve or thirteen years old, and the new pleasures that have come to complement the older ones never constituted any kind of rupture, or even a shift in direction. The ensemble pieces from *The Magic Flute*, the *Jupiter* symphony—all of Mozart's work has remained what it was for me at the beginning of my adolescence.

In addition to music, I had a source of aesthetic enjoyment that gave me pleasures that were much more profound, more personally orchestrated, and even more spontaneous, since I could only describe them in language or through theory with great difficulty, and I often experienced them without even fully realizing it. I am alluding here to what has always been the most intimate pleasure of my life, one you would have to assign, for lack of a better term, to the vague category of "Landscape" or "Natural Beauty."

I believe I received little instruction in this realm of taste. My father must have been inclined as I was: his

passion for hunting and fishing and his keen naturalist's eye were both wedded to an intense pleasure in all things related to the outdoors. Though his drawings lacked any artistic style, they nevertheless demonstrated a remarkable sense for the shape of things, and for configurations of terrain above all: no detail of the land or weather escaped him. But, being as he was a resolutely antiliterary soul, he did not know how to communicate his impressions, and his theories, befitting a retired engineer of bridges and roads, had nothing in them to charm a child who always dreamed of "The Beautiful," and for whom *Art* was already an idol. I think my father, who devoted very little time to me, must have passed down his tastes through sheer heredity. I never learned from him how to look at a landscape, whether to admire it or dislike it. Unlike my father, my mother was my constant companion, but she was the least likely person in the world to devote herself to the observation of visible things. As she was very literary, and full of Romanticism, she thought she treasured landscapes that she couldn't even properly see. She taught me to love certain adjectives: "the silvery sheen of the olive tree," the *dove-dappled-gray* color of a lake. But I remember my surprise when I realized that she couldn't tell an olive tree from a green oak, and that she never knew very clearly where the lake stopped and the river began. As for myself, I retained clear images of places I'd left behind when very young, and I could perfectly envision the topographies of cities I hadn't seen since my sixth or seventh year.

This feeling for landscape seems to have been both absolutely spontaneous and personal to me, since it was very cleanly bifurcated into a kind of satisfaction that swelled to passionate and nostalgic love, and a distaste that degenerated into a thoroughgoing distress. I believe this binary (*beautiful: ugly :: satisfaction: distress*) is the indispensable sign of an authentic aesthetic affectivity, however much the tendency to only look for aesthetic phenomena *in art*, where everything conspires to induce satisfaction and banish distress, makes us too often forget it. I must have had access to another field of spontaneous aesthetic experiences in the beauty and ugliness of the people who were part of my daily life. It's true that, in this case, my perceptions are less clear, as I don't always remember physiognomies, and my memories of people take the form of moments, of a series of consecutive states, rather than of *posed* portraits. And my preferences here stem as much from gestures, or from specific moral or organic indications, as they do from form alone. Still, these preferences have nevertheless been with me since my childhood. It even seems to me that in certain cases the affective memory was filed away without any visual image at all: for instance, I think I can remember just how much pleasure I took in the beauty (or how much distress I experienced from the ugliness) of some of my nurses and maids and other individuals whose physical appearance I can't remember at all. It's quite possible that what's at issue in cases like these is only the *trace* of an occurrence, transmitted by memory

without an authentic affective recollection attached to it, but I have no reason to believe that the judgments of others—"this girl is ugly," "this lady is very pretty"—were responsible, and that I'd have somehow carried those judgments from one stage of my life into the next.

There are two other considerations that lead me to believe that, in this domain, I had aesthetic experiences at an early age. The first is that, from nine or ten, the age I begin to have consecutive memories, I seem to recall a feeling of boredom caused by the necessarily quotidian and relative character of human beauty (relative in the sense that it's dependent on lighting, on the pose, et cetera). This boredom has followed me throughout my entire life, preventing me from finding a sustained pleasure, the kind of *stereotyped* pleasure that I aspire to, even in the beauty of the most handsome individuals or the ones I dearly love, and transforming my aesthetic relations with the people in my entourage into a little drama full of surprises, expectations, and disappointments. The other reason to think that I had spontaneous preferences in these matters is that, while *beauty* has always attracted me, *ugliness* has just as constantly posed an obstacle in my emotional relationships, enough so that I'm compelled to hunt out with great care the beautiful details in people toward whom I feel friendly for other reasons.

Awkward and retiring in nature, brought up in unusual isolation, I had very little taste for grooming and dressing myself, but furniture and the details of the house began to attract my attention as early as thirteen

or fourteen years old. I never had the least taste for the objet d'art, by which I mean bric-a-brac, but as I grew older, I came increasingly under the tyranny of line and color when it came to the objects around me.

The above details should demonstrate that from an early age I had access to realms of aesthetic experience in music, in "natural beauty," and in human beauty that could have furnished me the emotions (or, perhaps more accurately, the states of mind) that I connected to the words *Beautiful* and *Ugly*, even if those same features escaped me in works of art, to which I paid only a scant, distracted attention in any case. I will soon return to the subject of this *aesthetic emotion, stored up and transferred from one thing to another*. But first I must continue to follow the development, or, rather, the diversion of my preferences in art itself.

From very early on, I aspired to become a writer, and an art writer above all else. I began to take on the mental habits of such a career around fourteen or fifteen.

Beginning around that age, my notebooks are full of wild disquisitions on the *Beautiful*, and on the connections between the *Real* and the *Ideal*, between literature and visual art. At sixteen I wrote a rather clever little philosophy of art. And at seventeen or eighteen, when my family moved from Rome to Florence, I regularly devoted myself to what I'd term the exploitation of art for the benefit of literature.

Allow me to linger here a moment, examining exactly what happens when art is used that way. All literary de-

scription is based on images stored up in the memory of the reader. Accordingly, the writer who describes a painting finds himself totally unable to evoke its true form in the mind of a reader who isn't yet acquainted with this particular work of art. Because of that, we can be certain that at least nine times out of ten (or ninety-nine out of a hundred), the description of a painting will never amount to more than a description of the objects represented in the painting. The *form*, through which the artist attempted to conjure up reality, will become a mere symbol the writer quickly deciphers in order to busy himself with the reality referred to, and with the entourage of feelings and ideas associated with that reality. Thus, there is here a substitution of the processes of one art for those of another, and attention is diverted from its proper application. The writer will naturally seek out elements that lend themselves to literary transformation; he will unconsciously be driven to give himself over more and more to associations tied to the painting's subject (and by *subject* I mean everything one could learn from a catalog), to the detriment of the specific effect that a work's form can have on a viewer, an effect that differentiates each work of art from every other representing the same thing.

This explains my very first, anomalous pieces on art. All while resolutely maintaining that the essence of art is in form (a theory I'd derived in part from philosophical considerations and in part from my taste in music), I never offered my readers anything more than descriptions

of the subject an artwork represented, and of the states of mind arising from that subject. I pause here a moment to refine my thinking in these difficult matters, typically made only more obscure by art criticism. The word *subject* ought to be understood here in its narrowest sense. For the moment, I'm not speaking of the useful material that I, as a writer, could derive from the anecdotal or dramatic event, nor do I mean to indicate the attraction or repulsion I felt in front of a canvas representing, for example, Apollo surrounded by the Muses, rather than one that depicted drunks behaving in a disgusting fashion, although that sort of distinction also played a significant role in my preferences. I'm trying to get at something subtler here, something that is easily confused with our authentic aesthetic perceptions: the preference in a canvas for chains of ideas that would be pleasing in real life. For the longest time I thought that I had more of a taste for Signorelli than I really did, only because Signorelli painted models who would have been quite beautiful in real life, and whose physical beauty vaguely resembled that of classical predecessors. On the other hand, I had an obstinate prejudice against Botticelli, because his Virgins and Nymphs were examples of physical types that would have been sickly and sullen had they been incarnated in real women. Every time I looked at Signorelli's *Last Judgment* or the *School of Pan*, what I saw was the presence of ephebes, and this immediately called forth vague visions of classical statues (via an associational process that is the essence of even literary art). Even

more than that, it summoned up a *feeling of admiration* particular to thinking about classical artists and their young men, Achilles, Paris, Hippolytus, et cetera, along with the Doryphoros and Apoxyomenos.

As an aside, I want to draw the psychologist's attention here to this example of an aesthetic emotion preserved in an almost abstract state and transferred from one object to another. This state of mind, this sympathetic *synthesis* (to use the term in the profound sense given to it by M. Paulhan) kept me from lingering on certain formal particularities of Signorelli that make him one of the primitives least suited to my personal temperament. It kept me from noticing his heaviness and bombast, for example, and other qualities we don't have names for. The idea, on the other hand, of a certain, slightly sickly preciousness in Botticelli, an element of convent sentimentality and bad-faith mysticism, led to an affective synthesis that was hostile to the work of that great master, and which ran counter to my actual assessment. The ill will tied to this chain of ideas was so strong that even the name "Botticelli" was enough to summon it up, and years passed before I ever noticed that two-thirds of the works attributed to the painter had none of his authentic, particular qualities. I felt a sense of repulsion for the *represented objects*, the real types, the facial expressions—in other words, for parts of the work that were not its essence, and which depended to a large extent on chains of ideas, or at least on recognizing and transforming forms into images and emotional states.

I want to specify at this point in my confession that I don't intend to limit aesthetic interest simply to pure form. Every aesthetic phenomenon, even in architecture and pure decoration, normally consists of an almost inextricable *inter-action* between the perception of form and the suggestion of the represented object. And this continual interchange between the pleasure (or distaste) caused by the form, and the more or less abstract emotional states summoned up and imputed straight to the *subject*—this interchange is the very stuff of aesthetic experience. As psychologists, we're only too likely to tell ourselves that the *normal* or *legitimate* phenomenon is the one that's easy to describe. We cut slices out of living experience, and in so doing, we see life itself elude our grasp. It's precisely because I'm recounting my artistic evolution as it really happened that this memoir runs the risk of completely muddling my readers' prior notions.

The above considerations are a necessary context for understanding how my habit of making literature out of the subject matter of art substantially prevented, or at least obstructed, the development of authentic preferences, spontaneous and personalized attractions and repulsions of the sort that I'd already had since adolescence for music, landscape, and other sorts of aesthetic impressions I encountered in everyday life. I would add to this, before I move on, that the historical studies that occupied me in the early years of my literary career (*Studies of the Eighteenth Century in Italy* and two books on the

Renaissance) led me to seek out theories on the moral character of races and ages, an approach which in any case had been made fashionable by Michelet, Taine, and others. I directed my attention there rather than to an intimate acquaintance with art taken on its own terms, or a notion of its relationships with the mind of the artist and the mind of the spectator. We'll soon see the detour it took for me to wind up in the authentic presence of works of art, and to find there the phenomena of attraction and repulsion that mirrored those I already knew in other fields of aesthetic experience.

I should first lay out a handful of points that will be crucial for this story. Outside of my reading, I never received any sort of education that could have checked my overly literary tendencies. I drew from memory throughout my childhood, until the moment around thirteen years old when I discovered that the written word lent itself more easily to the expression of my daydreams. But I was never taught to draw and I've never really practiced the art, with the exception of a few months spent learning to copy the portraits I thought I needed for the historical work that kept me busy at the time. Accordingly, my visual memory, however good it may be and however much I find it a source of great enjoyment, has always lacked the kind of precision one gets from a long habit of looking at something in order to draw it. I never developed a knack for translating what I saw into pictorial forms and vice versa. Finally, for years I suffered from a kind of timidity when faced with questions of perspective,

anatomy, et cetera—the same kind of bashfulness that a gifted amateur musician might have had if presented with a thorny issue in orchestral counterpoint. My ignorance gave me the illusion that I was faced with a kingdom of mystery whose borders I dreaded to cross. It seems likely that, for a long time, the thought of my own technical incompetence kept me from occupying myself with the *visible form* in art in the same way that my eyes and feelings were ingenuously employed with respect to natural objects. Could one judge such things adequately without knowing if the foreshortening was properly executed, if a perspective was incorrect, or if a canvas had been repainted? And it was only later, after conversations with professionals—painters, sculptors, and art experts—familiarized me with these things, and after an intimate friendship with a very knowledgeable individual convinced me that technical understanding didn't alter authentic aesthetic experience in the slightest, that I began to approach the work of art without fear, and without burdening it with historical interest or literary preoccupations.

Despite these circumstances, which hindered the spontaneous evolution of my aesthetic tastes, there is some evidence to indicate their natural tendencies. From fourteen or fifteen onward, I can remember often posing myself the question of what exactly made the difference between the human figure in reality and in its painted representation. Without being able to formulate an answer, I realized that art had a special way of translating

the anatomical structure into lines and planes, and this metamorphosis, whose nature I couldn't at all guess, pleased me even more. Another clue: after I'd started visiting museums again, around sixteen or seventeen years old, I was tortured by what was for me an unsolvable enigma, one that I always chased from my mind as quickly as possible, only for it to resurface again later. The puzzle was this: How is it that works of art that reproduce exceptionally perfect anatomical forms (and above all statues, the ones by Sansovino or Canova for example) can still seem banal and even trivial? This paradox plagued me for years, until the age of twenty-five, when I finally gave an explanation for the phenomenon in my book *Euphorion*—an explanation that certain individuals were kind enough to find brilliant, but which is far from satisfactory. Other clues: a feeling of boredom or blockage when trying to look at certain canvases once I'd "extracted," as it were, their historical or literary content, and an inexhaustible attraction to other paintings (Andrea del Sarto's *Madonna del Sacco*, for example) that hardly lent themselves to literary exploitation. In the same way, I felt a feeling that verged on physical disgust when I looked at the too-rounded contours of a late Raphael, or of the elderly Michelangelo (e.g., *Last Judgment*), and above all in Tintoretto, whose marvelous colors could never compensate for an ineffable void, a bombastic quality, something I'd almost describe as gaping in his canvases. Almost my entire life I've had an instinctive antipathy for Titian's *Assumption*, despite a

thoroughgoing adoration for his early paintings. Similarly, the sickly affectation and mystical sentimentality of the figures in Perugino could never stem the powerful attraction of his landscapes with their vast lines, their pure and airy skies, and their monumentally severe composition. Since the age of sixteen, I've noted a marked preference in myself for the Doryphoros above almost any other work of antiquity, even though this statue is emphatically nonliterary: I loved it for the arrangement of *planes* and independently of its anatomical structure. And another clue: the feeling of boredom and even aversion that sometimes gradually replaced the initial pleasure provided by an artwork. I've had to get rid of photographs and casts (the photographs in the style of Burne-Jones, for example) because I found their particular plastic characteristics unpleasant once the literary or sentimental appeal had been exhausted, however much I was unable to determine the true cause for this shift in feeling. For months, I suffered a cruel disappointment in front of the long-coveted bust of a person I'd deeply loved. I tried time and again to explain the feeling as the result of a lack of resemblance. But later on, my studies led me to understand that the bust was simply a failure from the point of view of the arrangement of its planes and the play of light across them.

On the other hand, I noticed a constant and increasing affection for certain works of art (the relief of Orpheus, some of Sargent's sketches), and for pieces of furniture and humble ceramics I've lived with for years.

All in all, everything leads me to believe that while my literary activities distracted my attention from the actual artwork, so that I could extract its subject matter and insert it in a parade of associations (I was even, for a time, in the habit of describing canvases as if the scenes really existed, treating a *Fête champêtre* like an actual garden party), all the while filling my *verbal consciousness* with chains of imagery, another consciousness destined for visual memories was furtively and unexpectedly producing authentic connections to art, discriminating between works, organizing my preferences and aversions, and storing up not only art images, but also emotions, ones as clearly aesthetic in nature as those linked to a Mozart symphony or an Italian country vista. Looking at my writing, I think one would find, along with the literary tendencies that led me to latch onto anything that could lend itself to description or symbolism, that I also had an almost automatic aesthetic discernment. That discernment was increasingly insistent, pushing me to concern myself with beautiful things rather than ugly ones, and to store up what I'd venture to call the *specific emotion* of each work—to distill an essence of it, an affective *halo* that reproduced in the reader the feeling awoken by the canvas or statue in question. But I was destined to eventually enjoy art in a much more direct and intimate fashion, and to see it take a place in my life analogous to music, landscapes, and all those objects and individuals in my daily surroundings that escaped finer classification. The development that led to this took place in a way I

didn't expect, and it might seem paradoxical to those who haven't experienced something similar themselves.

Outside of my literary work, I tended to use art as material for purely philosophical, hypothetical discussions, and, even more frequently than that, as an object for scientific observations.

At twenty-three, I'd published some short pieces on the aesthetics of Hegel and Taine, on the relationship between speech and music, and, primarily, on the impersonal evolution of form in art. I felt an ever present need to make aesthetic phenomena, both objective and subjective, conform to the rubric of science. So when I, by chance, found myself in the intimate company of people occupied with archaeology and with the school of art criticism associated with Morelli, it was perfectly natural that I became interested in their work, and that I gave up, without a backward glance, the literary output that had won me a moderate success. Aesthetics then became what it had destined to be for me since my youth: not a mere exercise of imagination and feeling, a pretext for phrase making, but a historical and primarily psychological course of study. I tried to get to the bottom of the origins of art, of its influence, the vicissitudes of various schools, the evolution of form. And, in doing so, I approached the work of art with an absolutely objective spirit. In other words: I *looked* at it with every last scrap of my attention.

And so! This purely scientific interest, which won me the opprobrium of many of my friends, who saw my ap-

proach as a sort of apostasy and insult to feeling, led to the full blossoming of what I'll call my aesthetic life. The drive to understand works of art, and the need to examine them and compare between them, led me to put myself into constant and direct contact with them. When I was obliged to experience their reality in the same way that we experience the cities we live in, the individuals that surround us, and the furniture and instruments we make use of constantly, I began to feel for canvases and statues the same spontaneous and organic attraction—or boredom, malaise, and repulsion—that came naturally to me in my immanent and unconscious relationships with the visible things in my environment. Aesthetic pleasure and displeasure, it seemed, were phenomena that qualified *attention*. Now, for the first time in my life as an art writer, I devoted my full attention to canvases, statues, and architecture, instead of letting myself be distracted by poetic suggestions, or even wandering right off into literary amplifications. The scientific study of artistic phenomena killed the dilettante and rhetorician in me, along with the author of facile historical hypotheses, and replaced that cast of characters with the naivest naïf, as innocent as a stonemason, potter, or printmaker, the kind of person who confronted a practical problem and was obliged by her sometimes charmed, sometimes aggrieved attention to resolve it in an aesthetically pleasing manner. And I can promise the reader that the more I was driven to examine artistic harmony with purely scientific aims, the larger grew the gulf between a sense of

aesthetic satisfaction that sometimes arose in my experiments and the boredom or feeling of waste that arose in others.

Visual beauty and ugliness were now real for me, because my attention had to latch onto the form of which they are qualities. I lived intimately with art. Is it surprising, then, that this intimacy should have taught me a real affection, on the one hand, and a real irritation on the other, the kind of disgust that all forced contact causes the mind subjected to it?

There I was, living in a real relationship with artworks and learning to recognize my own preferences and aversions because of it. Were these preferences and aversions, brought out by my studies, what I might have expected from my spontaneous tastes in other areas? I can answer this question, which I've often asked myself, with a categorical *yes*. At forty-six, after twenty-five years of literary work and ten years of research in art, I believe I can recognize the same aesthetic character that one might have seen in me as early as at fourteen or fifteen years old.

Aesthetic Responsiveness:
Its Variations and Accompaniments

Extracts from Vernon Lee's Gallery Diaries, 1901–4

The following extracts from my Gallery Diaries of the years 1901–4 contain the rough material of personal experience whence have arisen the views which have confirmed, but likewise qualified, those expressed or expounded by me in that first attempt at psychological aesthetics entitled "Beauty and Ugliness." For, while gratefully acknowledging (in three of the foregoing essays) all that the study of Messrs. Lipps and Groos has done to enrich and clarify my ideas subsequent to my collaboration in "Beauty and Ugliness," it is desirable to point out that these ideas have invariably arisen from, or been tested by, my own personal introspection. I point this out not to avoid any charge of plagiarism, which would be as absurd as contemptible where community of views is the result of a convergence of studies and speculations; but because an essential of my own view of these matters is precisely that aesthetic receptivity or (as the *Einfühlung* hypothesis suggests our calling it) aesthetic *responsiveness* is a most complex, various and fluctuating phenomenon, and one upon which we must now cease to generalise until we have analysed and classified its phases and factors and concomitants in the concrete individual case. But these extracts from my Gallery Diaries contain also implicitly the method of my own contribution to such analysis and classification. This method has aimed above everything at keeping these delicate processes of feeling and imagination as free as possible both from self-suggestion and from that artificial isolation of separate factors which is bound to falsify

our knowledge of phenomena whose very nature is to be complex and unstable and as dependent upon inhibitions, abbreviations, substitutions and summations as upon any more elementary psychological factors. Indeed the value of this method is largely due to its having arisen spontaneously and unintentionally. These extracts will show the reader (and herein lies one of their uses) that the examination of certain purely objective matters led to the question: "How do I behave in the presence of a given work of art?" "How do I become acquainted with it?"; and that this led, insensibly and at first unconsciously, to a series of other questions: "How have I perceived and felt today in my relations with given works of art?" until little by little I have found myself with so many introspective data to verify and compare that there has ensued a deliberate system of noting down all the factors and concomitants of my aesthetic processes which cause them to *vary from day to day*.[1]

Vary from day to day. In saying this I am forestalling one of the most important generalisations which have resulted from my own observations and those (which I shall now put before the reader) of two persons who have kindly assisted me.[2] This generalisation is: that our response to works of art in general and to any work of art in particular varies from day to day, and is connected with variations in our mental and also our bodily condition; or, to put it otherwise, that there exist in experience no such abstractions as *aesthetic attention* or *aesthetic enjoyment*, but merely very various states of our whole

being which express themselves, among other results, in various degrees and qualities of responsiveness to works of art.

1 Cf. Oswald Külpe, "Der gegenwärtige Stand der experimentellen Ästhetik," *Bericht über den 11. Kongreß für experimentelle Psychologie* (Leipzig: Verlag von Johann Ambrosius Barth, 1907), pp. 32–33: I am happy to find that so methodical an investigator as Herr Segal is described as having found that "from one day of experiment to another there was a 'revaluation of values.' The same (elementary linear) figure would one day be the most pleasing and next day the most displeasing He (Segal) rightly insists upon the importance of an aesthetic attitude, which eliminates all memory tendencies which are foreign to aesthetic apperception."

 . I would draw attention to the fact that such an "attitude" as that imposed by Professor Külpe on his experimental subjects must not be sought for in my own observations, whose interest consists precisely in their being, so far as possible, a faithful description not of experiments but of spontaneous occurrences.

2 [Editor's note: We have chosen not to include the observations of Dr. Maria Waser-Krebs and Clementina "Kit" Anstruther-Thomson in these excerpts, as the points they make are explored in greater depth in the author's notes.]

*

* *

This inquiry implied *a study of what took place in myself in the presence of various statues, what associations of ideas, what feelings were awakened, and how I reacted psychologically both towards the visual form of the statue and towards the thing which the statue represented or the emotion it expressed.*

These two totally separate problems (whose only original connexion was that they might lead, and did so lead, to my abandoning two theories I had upheld in "Beauty

and Ugliness") became practically connected in my Roman gallery observations. The study of each speedily reacted upon that of the other. The more I observed, both objectively and introspectively, the more queries and problems presented themselves. After the first day I found that I was examining not only the work of art, but the consciousness in which this work of art was reconstituted.

*

* *

April 17. *Terme Museum.* "I am beginning to suspect that we should give but little importance to the *miming*, where it really exists, of the gesture of a statue. I mean of its *human*, actual gesture as distinguished from the *movement of lines* There seems no reason why perception of form, i.e., of *dynamic lines*, should be in any way connected with our own gesture. What probably is thus connected is the *recognition* of gesture: i.e., the rapid completing of a very partial visual impression by remembered experiences of our own To begin with: I think statues are not often really doing the action we attribute to them. I am now looking at a *Muse of Tragedy*, one leg raised and the other bearing the weight of the figure. But in reality what the *lines are doing* is a combination between the outline of a mountain group and the *mass* of a fluted pilaster. I think we are cozened by the *vivacity of lines* into thinking they give what with reference to our other experiences we *recognise* as the gesture of the statue. In fact I think any *mim-*

ing on our own part will be in proportion, not so much to our present aesthetic perception as to our awakening of memory images; a memory reviviscence which ought, on the whole, to disturb our present contemplation, i.e., if looking at a statue's hand makes me *think* of my own hand, then I may have a sensation in it; but not if I see that other hand only *as form*. This would explain why dramatic or pathetic expression is less realised by people who look at the form. Verify this notion on *Laocoön*

"Yes, decidedly it seems to me that I *realise* better that brutal *Gladiator* (Roman bronze, in Terme Museum) when I too sit in that position or thereabouts. But what I realise is not the form but his gesture; similarly his position makes me feel, even more powerfully, that looking at him is like looking at a real sitting man. And the peculiarity of this bronze is that it is singularly without *aesthetic weight values*. The feet don't seem really to rest much more on the heels than my own feet do. The arms are very decidedly resting with their real anatomical weight, i.e., but little, on the thighs, and the thighs have very little *spring*. The conventional, i.e., aesthetic, part seems to begin with the head and shoulders.

"Looking again at the *Subiaco Niobid*, I cannot say I feel the smallest call to do his attitude. And on reflection, I don't see how I could, for I doubt whether it is in the least a human one. To begin with, seen from one side the activity is much greater than that from the other, merely because the thrust of the lines is more complex. N.B.—This is not saying that in *thinking* of this Niobid I

might not inwardly or outwardly mime him: but that would just be because I no longer saw him well, but substituted a composite experience-image of my own."

Thus introspective observations become more discriminating. It is henceforth no longer a question of the *statue in the abstract*, but of *individual concrete statues* and my response to them. I begin to observe spontaneously and then to study deliberately what takes place in me before good or bad statues, before architecturally built up or realistically expressive; and finally, what associations of ideas, what feelings awaken or lapse in me, how the subject represented by the work of art acts upon me, as well as the visible form, that visible form which constitutes its intrinsic existence.

*

* *

Vatican Museum. Notes on several statues, always from the point of view of gesture and of the movement of lines.

"*Apollo Sauroktonos*: not the faintest tendency to *realise* his action. It is eternal, and the lizard will never stir.

"The *Ariadne*, with all her pretentious modelling and drapery, seems to me one of the worst statues in existence: a woman arrested in the act of falling off a sofa on which she is lying in a hideously uncomfortable position. The drapery, so far from keeping her in place, *as lines*, drags her down She is derived from the recumbent goddesses of the Parthenon: only here the legs, feet and

drapery contradict that mountain quality of the great original. It is the *inertness*, the visible tumbling *out of bed* which makes the public think that she is sleeping. 'One must be asleep in order to tumble out of bed like that!' we unconsciously say to ourselves.

"*The Belvedere Hermes.* How little such a statue tempts one to *mime* is shown by the fact that his head constantly attracts one upwards: now his head is very much bowed. Moreover his *planes* tempt one to walk round. Now, if anything, he is *walking downhill* Evidently in looking at real people we are perpetually spotting and identifying action and expression. The really *motor* side of aesthetic-perception is quite distinct from this miming—even contradictory to it. The fact of having 'motor images' of people does not in the least imply memory for the *balance* of a group or its lines. *Query*: What is the glance of architecturally composed statues? It must *be a way into the statue*, and must be one of the main lines of movement along its surface or profile. I think I have verified this for the *Hermes*; the awful Canovas are distinctly *looking out of themselves*.

"*The Apollo Belvedere* already has (probably because a pastiche) a little too much of the kindle and snort which makes him restless. But even with him, his glance never makes *us* look at what *he* is looking at, as the glance of real people, I think, does. (Note the singularly aesthetic impression of the glance of very beautiful real people—Princess V——, Mrs. S——, even Lady V——, their glance making us *look at them*—their glance drawing us inwards.)

"Verified about glance in *Demosthenes*. From the position of his head he ought to be looking at *me* when I look at him; but he never catches my glance. One reason for not marking the eyeballs is that doing so directs the glance outwards; the statue focuses. Now a statue ought, so to speak, *to focus inwards*

"Women do better in a gallery, are more tolerable than men, because skirts and hats make them in a slight degree architectural: and because the *action* of their gait is dissimulated. A 'well-hung' skirt is one which substitutes a more agreeable movement to the real one of their legs.

"Verification of question of the glance on ten or twelve statues. *Roman statues look out at one*.

"*Braccio Nuovo*. Verification of same question on my dear little *Musagetes*. Catching his glance I go first to the sunflower arrangement of folds round his belt, then up his extended arm by the curls round his head and the laurel crown.

"The glance seems to me to be *initial*, always—or nearly so. Our human habit makes us (where there is no objective movement) go straight for it; and in the good statues it directs our eyes along the statues' highways. Probably on a mountain a well-placed church or tree fulfils this function."

This inquiry is continued the following days. *Terme Museum. The Apollo.* "It seems to me that here the point where we leave his glance—or think we leave it (for I seem to look at the eye itself, then to follow the glance down the nose and as far as I can go, without moving my head)—

is at the pectorals. My eye goes round them to the left (whether from habit of reading from left to right or because his head is turned to *my* right I can't tell), then round the shoulder and head and down the opposite side

"*Terme Museum. Dionysos*. Here it seems to me that his glance makes me catch the middle of his bent arm and travel up from that

"It struck me yesterday at the Cast Museum that it is the *turned head* which first invites one to take in rather more than the mere full-face view of a statue

"The result of this inquiry about the *glance* of statues, and the way it leads us in our perception of their aesthetic (as distinguished from their anatomical) form, is summed up in two sentences of that diary, representing the objective and the subjective side of the question. 'The work of art is, so to speak, its own showman,' and 'The total impression of a work of art is, I think, the sum of a series of acts of attention.'

"This latter formula agrees, to a degree I was not then aware of, with the trend of recent *introspective psychology*. But the psychological and introspective side of my inquiries was, almost unnoticed by myself, growing and ramifying. While noting down the relation between the glance (that is to say, the direction of the eye) of the Terme *Dionysos* and that statue's general lines of composition, I found myself adding, 'One ought to inquire into a specific pleasurableness, I don't know how to call it, of beautiful sculptural anatomical form as such. Is it

the sense of planes in detail? Or the feeling of youth and vigour, human comeliness?'"

<center>*</center>
<center>* *</center>

April 22. *Vatican Museum. Hall of Muses.* "... The *forward* movement so strongly marked in the *Apollo Musagetes* (I expect one would feel forward tension in thinking of him, and I find I instinctively hold my breath and dilate nostrils in looking at him) is not in the least given in his legs, which are little indicated and that little singularly inert (save the raised back foot) but in his drapery, which is rippling back in his robe and distinctly coming forwards in his mantle; the going back of the one half and the coming forwards of the other half of the lines (in the drapery) is a first-rate illustration of Lipps's favourite formula of the sense of movement produced by lines whose tendency seems to clash. It seems to me also as if while the ripples of his hair distinctly flow backwards, the spikes of his laurel wreath as distinctly press forwards.

"This statue (the original of which was probably by Scopas) is a wonder of movement of lines If my *experience* tells me that there *is* movement, it is not that of a sailing ship (though we should describe both as sailing, advancing *against the wind*) but rather of a succession of waves, where the first falls back against the advance of the second The statue of *Lucius Venus* has as much

action as two ugly English boys who come suddenly in, and that apart from his restored arms He is also firmly and sheepishly looking at an object in the room."

Several observations of the same kind follow: Why does the drapery of the *Venus Anadyomene* not seem to slip off? Walk round the *Hermes* searching for the union of planes. "The Romans discovered that the ear was not a rosette, but an organ capable of individual expression—hence the look of *cocking* them in their busts"

Comparison of the realism in movement between mediocre Roman art and the architectural quality of Greek art summed up, "Is not the *Caryatid* the central symbol of great sculpture?"

*

* *

"I am distinctly annoyed by the eagerness, the forward action of the three very bad *Tyrannicides*. They keep catching my attention and not keeping it; it is like having one's name called repeatedly. This action is an intrusion in my life; what relief in the plash of the fountain going on steadily on its own account! All the statues—all or nearly all bad—of the room (since rearranged) have the aggressive self-assertion of photographed people. Even poor old crucified Marsyas, whose lines are not even pulled by his position, is fixing a bust on the floor steadfastly. How the *Baptism* by Titian has the same permanence as in good statues—self-continued, satisfying."

April 26. *Museum of Casts*. Notes on composition in sculpture. The frivolous quality of statues lacking *architectural weight*.

The disagreeableness of real *action* in a statue is independent of the violent and instantaneous character of the action.

"I do not think even the most four-square statues intended us to take root before them. The very fact of their having subsidiary sides makes us move round, though it prevents our moving round without stopping. And the head always invites inspection from every side. There is therefore a sort of reinforcement of the emotion produced by the chief view, a consciousness of subsidiary beauty, of cubic thoroughness which makes them quite different from a relief. This is quite different from the sense of roundness, or real existence in space. It is a concession to our habit of penetrating in and behind, to our sense of abstract bulk rather than to any knowledge that real people have cubic existence."

I would beg the reader to remark these questions of *summation* and of *cubic existence*, which he will meet with further on, and in constantly greater development. I have kept for the end of this instalment of my Gallery Diaries a note written in the Museo delle Terme and in the midst of my observations on our alleged tendency to *mimic internally* (*Innere Nachahmung*) the *represented* action or gesture of works of art.

*

* *

Of course all form which we recognise as human awakens or can awaken the various orders of feeling which are awakened by human beings: sympathetic, voluptuous, painful, etc., because the act of such recognition means a reference of them to memory impressions which must be more or less saturated with the human feelings elicited in contemplating the human realities of which those impressions (images) are the residue. But this emotion is evoked just in proportion as we refer the artistic form to the human reality, i.e., in proportion as we dwell little on the work of art and much on the memory impression. Literature, appealing entirely to such memory impression, has therefore a "moral power" quite different from that of art. The more a statue makes us look at it, the more it holds us by *its* reality, the less *moral* (or immoral) feelings we shall have. These are got largely by substituting the *word* for the *form*. If men have been in love with statues, it is because they have substituted for them the flesh and blood images of their memory.

It is in this way that art, by reversing the process and furnishing us with artistic images and emotions to be revived by *real* things—by accustoming us to translate reality into form (instead of form into reality)—can purify and elevate the contents of our consciousness. The same with music.[1]

These observations made in museums were resumed in Florence in the winter of 1901–2, and this time especially in relation to pictures. They begin December 3, by notes on the movement of lines, the greater or less tension and cohesion in the composition of Filippino, Mariotto Albertinelli, Giovanni Bellini, and Leonardo. This is the note made on the *Allegory* of Bellini: "After looking a little I seem to *flatten down*[2] the water, which at first looked rather a vertical wall, and in doing so I feel as if I were relieved and breathed more freely. Perhaps the flattening is a subjective effect, perhaps the slow perception of reflections, etc., on water. When a picture pleases we probably do a deal of subjective correction to it."

December 6. "I begin deliberately to ask myself, 'Why does this picture please me?'—'Why does this other displease me?' making at the same time an analysis and an inventory in both cases. As a general result the simplest attraction to distinguish is that of colour[3] and that of certain tangible qualities, such as softness, and warmth of the flesh, etc. I give here the analysis headed: 'Why I *don't* like *Lorenzo Monaco* (large Madonna and Saints).'

"(1) The colour—acid, shrill, crude, opaque (probably repainted).

"(2) The swarthy, sooty faces.

"(3) Their being set like ill-mended crocks on shoulders.

"(4) The idiotic glowering which makes me feel queer.

"(5) The vague, delusive, changing relations of body and head in space, like masks and bats, waving in space,

but waving at wrong discordant intervals, so that I find a protuberance where I expect an emptiness.

"(6) The limpness of arms and hands, particularly contrasted with truculent pose of head and glance.

"(7) The total scatteredness, idiocy, fussiness.

"N.B.—On the whole one of the ugliest pictures I know."

Same inquiry. *Domenico Veneziano*. "At first I don't care much, and have a slight difficulty in attending. Perhaps the acid magenta-ish rose and acid pistachio green chill me. Or rather the sourness of the blue against it Then I am a little put off by the extreme lightness of colour. At first the saints have no body, having so little shadow. Only little by little I perceive the body due to matchless poise and pressure and directness of thrust. But something in the relation with the background puts me off—there doesn't seem room for more than half of them against those pillars; they are like wafers. Is it the bad perspective worrying me? But I get charmed by the lovely (unrestored) colouring, cold rose, warm grey, vivid geranium; by the exquisite light colours of the floor. The spring of the little Gothic arches delights me. The splendid line (mountain line) of female saint; the ship-like, swan-like poise of her head (utterly unhuman). The rock-boulder quality of Saint Francis; his stooping head not taking off from his soaring erectness. The fine form, decided gesture of Saint John. The flattening of all the faces delights me. I enjoy the pane of glass, so to speak, between us.

"N.B.—Of course this very fine picture is totally without imaginative or emotional quality, the figures are like chairs and tables simply."

Giorgione, *Moses*. Why I like this picture:

"The landscape makes me a little breathless by its brown colour, but I enjoy going into it with the eye: I am not sure whether it suggests real landscape The other colouring, local passages, contrasts, enchants me: the shot quality, laced with white and rose

"Then the deft, *pat* painting, e.g., in chains, fringes, folds of linen. This indicative slightness gives me high pleasure.

"Then the roominess, none of that frightful crowd. (I am thinking of *Lorenzo Monaco*.)

"Then the figures' relation of bulk and pressure. Then a certain limp, *posing* way of standing. The plant quality about the head and neck. The extreme unconcernedness, yet thorough *being there*; in this very scattered group and vague action, a mysterious unity.

"A sense of leisure, seriousness, effortlessness. Life easy, but very grave.

"This picture is not exhilarating, but very reposeful. Except in the two lovely youths, no expression and no discoverable literary suggestion or reminiscence. The poetry is visual; you could not make a sonnet about it.

"I think the easiest thing to find out whether one likes is the colour. Certain blues and lilacs catch me at once with a sense of slight bodily rapture, unlocalised but akin to that of tastes and smells. Also certain qualities

of flesh, its firmness, warmth (*realism* undoubtedly), as with Titian's *Flora*. This picture gives a sense of this flood of life: heightening one's own (this seems very unaesthetic, perhaps it is). I confess to a wish to kiss—not to touch with fingers—the *Flora*'s throat. The dreadful repainted flesh of the *Duchess of Urbino* gives me a horrid sense of touching cardboard."

Uffizi Gallery. December 9. "A very vague notion which came to me in the gallery, and which I note down in its vagueness, trusting that circumstances may make it clearer. After all, may not the perception of form be, normally, a subconscious process accompanying the conscious process of recognition of the subject of the work of art, the utility or name of the thing represented? And would this not explain our inability to say *why* we like a form, as opposed to our manifest facility in saying *what* that *form symbolises or suggests?* In other words, are we not pursuing a necessarily unclutchable phenomenon in our pursuit of perceptions of beauty and ugliness? First, consider that if what we call beauty represents a desirable complex of organic modes, and ugliness the reverse thereof; would not the stability, the constancy of repetition of the act of preference tend to make it very automatic, and of a degree of 'Fusion' which defied analysis? Whereas the 'spotting' of qualities, the inference of qualities, the reading of the symbol, the calling things by name and evoking their associations would necessarily be exceedingly varied; varied because it depended upon the synthesis of desire, need, habit, attention, which in

all cases would differ The real world phenomenon is so individual, so different from the phenomenon of yesterday or a minute ago, that it is bound to be conscious and distinct.

"Secondly, for practical purposes there is no need that we do otherwise than react correctly to aesthetic stimulations, and the more automatically the more safely and correctly. Whereas for practical reasons the mere 'spotting,' *naming*, recognising, is most advantageous when very conscious; if for no other reason because such 'spotting' often tends to concerted action between various individuals, and therefore requires to be communicable. The habit of recognising what a picture *represents* is intimately connected with the ability to tell someone else, or store it definitely in one's memory in the same way that one notes for oneself and others, 'in such a place I noticed such and such an object useful or dangerous in such or such cases.' Hence the recognising process would have a rich analytic vocabulary, while the aesthetic process of attraction or repulsion would, as indeed we find, have no vocabulary at all; for our names of visible qualities none of them denote *aesthetic ones*: red, blue, tall, long, triangular, square, tell us of no *aesthetic* peculiarities. For those we must go to the names of *our moods*: pleasant, unpleasant, harmonious, jarring, unified, etc.[4]

"The long and short of all this is that normally, when we look at a picture or statue, we *think* the subject, and *feel* the form, and express the first in rich and varied lan-

guage intelligible to everyone, while we only indicate the *effect of the other on us* in vague terms not much more than translations of gestures and cries, 'I love!' 'I'd rather never see it again,' etc."

Florence, January 19–20, 1902. *Note on the interior of the Cathedral at nightfall.* "It is on such misty days, and towards dusk, that churches reveal their qualities of spatial arrangement. The people become mere faceless gliding ghosts; one is alone with the building. I note the emotion of heightened being, of vitality as it were from one's head, which is carried higher than usual. I feel lifted with a lighter tread, at the same time there is absolute restful satisfactoriness; not rest in the sense of self-abandonment; but not any of the excitement of French Gothic.[5] How anyone can feel religious *awe* in such a church, I cannot conceive: one becomes a kind of god, and the place is a god.

"The next day under crude light, the people, the ugly arches become visible too much.

"Next morning. Yesterday, being tired and harassed, I walked to the *Opera del Duomo*. As usual the people in the streets on a winter day depressed and grieved me; they seemed a variety only of that foul town mud one picked one's way in. On the staircase of the *Opera del Duomo* my eye met a fragment of frieze, carved and set with Cosmati work. I had a very vivid sense of *liberation*, of having slipped into another world, in which mud, bodily and mental, does not enter; a feeling of being where *I ought to be*."

While staying in Rome during February and March 1902, I resumed my notes about the Movement of Lines and Real Movement.

February 17. *Capitoline Museum.* "Marcus Aurelius seen from the window Evidently if the horse had anything like *real* movement, we should be distressed by the pedestal over whose brink the next step must take him. The movement is mainly due to the resistant line of the quarters, hind legs and tail, the forward thrust of Marcus Aurelius's arm Curious that the raised front leg in which the *real* action of a real horse mainly resides carries the eye back, and with its hoop-like line is what prevents the horse going over the pedestal. The mane, waving backwards, does much the same, and probably the bridle did it also The *real* horses—to be sure only Roman cab-horses!—move only because they change place across my eye and across the square. But they have no *line of movement*!

"N.B.—Examine to what extent the knowledge how things in reality grow or lie affects our sense of movement: knowledge, e.g., that the *mane* grows backwards from the head.

"Roughly speaking, even the very worst busts have forms of neck, ear and jaw, mode of carriage of head, wholly unlike those of real people.

"A statue like the Capitoline *Venus* is not one work of art, but several, of which some bad. Seen from in front the only agreeable impression is due to our knowledge that she is *well grown* (for the limbs as such have no

beauty of line), physically pure, and to the sense of pleasant resistance and warmth of flesh (like Titian's *Flora*)—in fact a realistic pleasure.

"Seen from the side and back she becomes a mountain composition, interesting like a Michelangelo

"The work of art is the joint product, the point of intersection of the process of the attention of the artist who makes it (hence Löwy's *memory images*, etc.),[6] and of the process of attention of those who look at it.

"Let us try to reconstruct both these. Ask ourselves about, e.g., antique statues. What were people doing, thinking, attending to, when statues offered themselves most habitually? Certainly not going round *en touriste*, nor like me at present, half killing themselves in trying to fix, possess, understand. The first way in which a human being meets any statue is when he asks, 'What does it represent?' and (as most tourists show) such meeting rarely goes any further, until we get to the artist's or archaeologist's attitude, 'How?' 'By whom?' 'Why was it made?'

"But we must try to understand what kept the ordinary beholder before the statue, or brought him back to it. First, I think, the statue, commemorative or votive, being there as a natural object, part of scenery or piece of furniture from which the attention could not escape.

"Secondly (this is at least the Christian condition), its being an *idol*, an aid to devotion, something on which the eye is fixed in prayer or in the desire to realise divinity.

"Hence we are quite wrong, we critics, in coming and staring at a statue as such. It is nearer the normal to *spot*

a given figure and feel attracted by *what it represents*—as I am attracted here by the thought and attributes of Apollo. The natural process for going into art is either, 'So *this* is Apollo'—or else 'O Apollo,' etc. But it is not, 'What the deuce is the value or importance of this statue?' or 'How does it answer to such and such a demand or definition?'"

This consideration will be resumed later, as we shall see.

The notes go back to other questions. *The Amazon, Braccio Nuovo.* "I am not sure, but it seems as if the quality of *flesh*, possible softness and warmth, certainly helped us to look at her, perhaps by a kind of physiological *Einfühlung*. It may perhaps be merely a question of planes, as in a mountain. But I suspect something more than form interests, the suggestion of a beyond, a life more than the skin, like the possibility of a forest, etc., on the distant mountain. Also, two *Diana* torsos, *Chiaramonti*, of which the drapery charms me. But I am attracted by the idea of the goddess vaguely—the woods, etc.

"When I said that we first make for the eyes of a statue and follow them I was mistaken. This happens only in bad statues, and the following of the glance has the destructive effect of carrying *us out of them*. What we do is, I think, to follow the *line* of the brows, or more properly the brow opposite our left (owing no doubt to our reading from left to right), to the circumference and thence upwards. For this reason a slight tilt of the head is a help, I think, by taking the frontal line of the right angle. I wish I could make out on what depends the *looking out* of Roman and realistic statues; and the reverse therefore

of good Greek work. It has nothing to do with the pupil being marked. The Terme *Dionysos* has the pupil clearly engraved, but is not looking, at least not looking *at*; whereas a very bad Roman Peter Lely–ish *Juno* (?) there has an amazing *looking out*. Probably it would be found to depend upon the presence (or absence) of *some arrangement of lines*, differing in each individual case very likely, which counteracts the outwardness of the glance. It is quite certain that one of the chief charms of, say, the Ludovisi *Ares* is exactly this thorough self-concentration of glance. It makes one think of certain words by Dante about the selfcontainedness of the Divinity. And it makes one feel similarly to certain old landscapes, i.e., Perugino's—and similarly to how one feels *inside* a building. One of the greatest delights of a work of art is when it *encloses* our attention, and that is why architecture is the most easily efficacious art, and sculpture, as a rule, the least so. 'Und Marmorbilder *stehen* und *sehen* mich an' (Goethe's *Mignon*). The good ones do the first, the bad the second."

It was following out such thoughts, which came to me, as we have seen, in the course of my *objective* study of works of art, that there shaped itself a distinct intention of studying the response of the spectator in artistic contemplation. Immediately after the note I have just quoted comes the following:

February 21. *Stanze di Raffaello. Heliodorus.* "The chief fresco gives me immediate and thorough pleasure. I find in my mind a phrase of Pergolese's *Salve Regina*,

'*Exules—Exules filii Evae*'—it goes with it. Goes also with the *Liberation of Saint Peter* and the *Miracle of Bolsena*, and portions of *Attila*. Impossibility of taking in *Attila* as a whole. I will try another tune. I try: themes of Choral Symphony: some Mozart: some Bach: nothing goes. I try and imagine the *Parnassus Apollo* playing Minuet of *Don Giovanni*: then *Bist du bei mir*: the Ninth Symphony chorus: then *Che farò, chi mai dell' Erebo*—I find he does play that *Exules*, though slowly, but Virgil in the corner and Sappho distinctly mime it.

"Looking at the *architecture only* of the *School of Athens*, I try again. The *Exules* enables me to see the arrangement of cupolas and arches, to take in very well the depth of the great waggon vault. The Ninth Symphony makes it all joggle. The *Don Giovanni* Minuet makes it (or my attention) sway and shake from side to side, with a result of carrying my eye out of the building.

"If I can trust myself the same applies to ceiling of the *Sala della Segnatura*."

February 23, *Capitoline Museum*. "I find that the *Lo Spagna Muses*, etc., give me a pleasure greater than Raphael's. It is a question of:

"(1) The Umbrian spatial quality—the form of valleys and hills, relation of skyline.

"(2) The still 'Primitive' angularity of line and reticence. But also,

"(3) Very much of this peculiar pale colour, extremely simple and cool, faded green, pale blue and abundant white, all very diaphanous.

"This Professor Groos would call 'sensuous,' but the attractiveness is wholly different from that of qualities of food or touch or smell: it is an emotional effect, an effect of moods.

"Ideas rather upset. It seemed as if that '*Exules—Exules*' tune helped me to see—or at least did not interfere with—most of the pictures, though it didn't seem absolutely to fit the Titian (*Baptism*). I didn't bring it to the Capitol, nor did it come spontaneously. As I was walking up a tune was knocking about in my head spontaneously, the *Fidelio* quartet theme. It distinctly did not go with any picture, nor did any other theme I tried, except that blessed *Exules*. I ought to say I was tired and had palpitations and didn't see well. Is it possible that *Exules* went not with the pictures, but with my palpitations? But, as I said, before going up the staircase my mind was full of the *Fidelio* theme. Of course it may be that a tune which goes with our momentary state helps us."

February 28, *Sistine Chapel*. "We are forced to strain neck and attention, and to bring mirrors. But in the periods of artistic progress, the work of art really does answer to the natural way in which it was, on the average, seen. The Campo Santo of Pisa, the typical *Salle des pas perdus*, the Chapel or Hall, where you waited for hours, is decorated accordingly. Even the *Loggie* of Raphael become different if we imagine ourselves on business here, waiting our turn of audience or taking the air in bad weather. The eye and interest go spontaneously, and return spontaneously, as we walk and talk, to these

histories and arabesques. It is reversing the whole process to go and look fixedly at a work of art, and then never see it again."

March 1. *Sistine Chapel*. "How little the real problems of art are appreciated is shown by the fact that no writer I know expresses any astonishment at the figures of the ceiling staying in their place. Yet this is a far greater feat than the mere mechanical holding together of the vaultings of Gothic buildings; and some of these figures, and of the most colossal, like Jeremiah and Daniel, actually lean forwards so far as attitude is concerned The fact is that not one of these figures has any weight as *human figures*, but acquires weight, shifts it or transmits it to another, exactly according as our eyes require to be pinned down, or forced up by turns I owe this—the first satisfactory impression I have ever had of the Sistine Chapel (though I had been there two or three times every year since 1888, not to say that I knew it very well when I was eighteen)—to my refusing this time to walk about, strain my neck or try to see like all the other poor wretches. I simply sat on a bench near the door, allowing myself to look now at the vault, now at the *Last Judgment*, now at the people, now at my writing—in fact tried to exist as one would if one were in this place for some purpose (if no other than waiting) quite separate from *seeing*. I should like one day to be here at a Papal Chapel. I seem to remember, in 1888, that the Palestrina Mass, etc., did enable me to get an impression. But I was ill and have forgotten.

"Very interesting to find that from the *Tribune*, even sitting, this marvellous composition is very much spoilt. The things telescope, and the movement of the lines being interrupted, the single figures begin to gesticulate. *This is a most important fact ...*

"It is worthwhile, in order to realise what art does, to stand on the altar steps and look from here at the ceiling. It is not merely that the subjects of the composition become unintelligible and people stand on their heads: the whole composition is chaos, and the prophets, sibyls and slaves, who remain quite intelligible, make one vaguely seasick. Of course, in this losing of the composition, everything drops on one's head."

March 1. Resuming the observations on the *melodic obsession*. *Raphael Loggie*. "*Exules* do *only* in part (e.g., 'Creation')—perhaps because of the various executions, or because *my step* in walking up and down is naturally not in that measure?

"I found I had in my head, walking up and down, a slow waltz, a fragment of Chopin, I think. But it didn't help me to see, on the contrary. Whether *Exules* is the *rhythm of my attention* when intense? I notice that while looking carefully at these frescoes (even *Constantine*) and even when writing at this minute, I am keeping my mouth tight shut and breathe hard through the nostrils, with *accent* on expiration.

"Whether it has to do with going up all those stairs? I was not out of breath at all but excited in breath and heart.

"*Exules* again all right for *Heliodorus*. All palpitation gone. I certainly seem to see better breathing through nostrils than through mouth. The open mouth is inattention. More and more I suspect all this breathing business is a question of attention.

"I can't say a picture is more agreeable on account of a given breathing—simply I see it better, and if *seeing it is agreeable*, why then pleasure is increased. Try same thing on bad pictures. Besides, isn't attention often *pleasant as such*?"

March 1902. *Uffizi Gallery*, Florence. (Question of *Inner Mimicry*.) "The arrow through the throat of Sodoma's *Sebastian* ought to give *me* a slight sense of discomfort in my throat. The fact that it doesn't points to something else diverting my attention. What is that something? When I say to myself, 'The arrow cut into the flesh, crashed through the bone and cut through the arteries,' I feel a vague sickness. When I cover the angel the arrow business becomes more painful; that cheerful, busy, very alive angel sets up, I think, a feeling which destroys the arrow feeling.

"Coming upstairs and after, I had a certain Neapolitan popular song in my head. It fitted onto the beating of my heart. As long as those palpitations went on, and that song, I couldn't see the *Saint Sebastian* properly."

1 Cf. an article of mine, "The Riddle of Music," in *Quarterly Review* no. 406 (January 1906): p. 227. "In this fusion, or rather this oscillation between the emotional suggestion and the aesthetic contemplation of music lies, perhaps, the moral and social function of art. For, whether a composition affect us as a beautiful and noble experience; faintly tinged, vividly tipped, with some human emotion, or whether it affect us as an emotional experience kept within the bounds of aesthetic order, shaped in aesthetic beauty, by the presence of musical form—whichever of the two possibilities we consider, there remains an action of the aesthetic element upon the emotional; and the emotional is probably purified by the aesthetic, as the aesthetic is unquestionably brought deeper into our life by the emotional.... Our emotions, our moods, our habits of feeling, are schooled into the ways of lucidity and order, of braced and balanced intensity ... of contemplative happiness, which are the ways of aesthetic form."

2 Waldemar Conrad, "Der ästhetische Gegenstand," in *Zeitschrift für Ästhetik und allgemeine Kunstwissenschaft*, ed. Max Dessoir, vol. 4 (Stuttgart: Verlag von Ferdinand Enke, 1909), says, p. 408, of the aesthetic line: "Sie muss, eben wie eine wirkliche Linie, in einem einfachen Bewegungsakt veranschaulicht und nicht erst durch die eigenartige Kombination von Akten erfafst werden, durch die wir uns zweidimensionale Ausbreitung zur Anschauung bringen." Also p. 422.

My own experience is that of a sensation of *leaving off and beginning again, a sensation of distinct change of motion*, in the eye, accompanying the recognition that certain portions of a painted surface are to be interpreted as *verticals* as distinguished from perspective *horizontals*, or *vice versa*.

3 Cf. Vernon Lee and Clementina Anstruther-Thomson, "Beauty and Ugliness," in *Beauty and Ugliness* (London: John Lane, 1912), p. 206.

4 I ought to have added: and to the names of our *modes* of movement: strong, slack, free, light, rapid, harmonious, etc.

5 Cf. Lee and Anstruther-Thomson, "Beauty and Ugliness," p. 201.

6 *See* Emanuel Löwy's *Die Naturwiedergabe in der älteren griechischen Kunst* (Rome: Loescher, 1900). Professor Löwy explains the combination in the same figure of profile face and full-face eye, of profile legs and full-face chest, etc., observable not only in all primitive art but in the drawings of children and savages, by such figures reproducing the memory images of what is easiest to understand and see and most interesting, which persist and impede the "seeing" of the model, the memory image being due to successive impressions, and preventing the immediate artistic perception of simultaneous aspects. In this connexion cf. Mr. Henry Balfour's extremely interesting anthropological study *The Evolution of Decorative Art* (London: Rivington, Percival & Co., 1893).

April 2. *Uffizi Gallery*. "Things which are disagreeable. In Rubens's big battle the fact that Henri IV's arm grasping a thunderbolt comes out at a wrong angle. Every time I look at it it gives me a peculiar shock. The sixth or seventh or eighth time, this can no longer be surprise, for I know it is there. The painful effect is partly that his arm, thinly and badly sketched in, is also out of plane (too far in the canvas for its sharp outline); but mainly that it stops the movement *of the man and the horse*. Now it does not stop it from realistic reasons. One can imagine the man riding forwards with his arm stretched out laterally, and the 'out of drawing' is no worse than other out of drawing in the picture.

"But that arm stretched laterally prevents the eye and *something more* (though I can't tell what—what I should call *me*) from pushing forwards into the picture, as the tail of the horse, the gripping leg bent back, prow-like beard, nose and helmet all make me push. It is of the nature of a wrong note, or rather of a trap, stopping *me*.

"The pleasure I take in this picture (when I cease to see that arm), or at least in its central figure, shows that it takes a minute to learn the rhythm of a master or a school, for it seemed gibberish at first, after coming from the Primitives. A distinct feature in this pleasure is a sense of intensity of pushing forwards and of concentration, far greater than a real horse or real man would have: a dynamic *unity of strenuousness*.

"The agreeableness, a certain vague sense of peace and harmony, on entering the sculpture room seems connected with the steadiness, the monumental quality, the absolute cubic size of the marbles, also, I think, with the fact that the values of their hair, flesh, etc., as substance and solidity are the same, and their drapery of course also."

From a long note on a repainted Van der Goes. "The hatefulness of everything being out of plane as well as out of perspective. I think the view is conceivable (?) but the ground is nowhere under the people. The Virgin and Angels are kneeling on a kind of almost vertical plane; and it gives one a sense of discomfort, very strong in the chest Of course also the Shepherds . . . are being precipitated, catapulted at a diagonal across this same vertical plane. It is not a question of anatomical attitude Apart from all this there is the fact that the eye (and *I*) are forced into an intolerable game of hide-and-seek, absolutely without rhythm, backwards and forwards in the picture. There are no roads into it or in it, nothing to keep *one* in place, and the constant discovery of new items—more angels kneeling or flying, more shepherds to dispose of in this chaos, is a positive distress

"De Bles's (formerly called Van der Weyden) *Madonna in brown landscape*. The ground under her feet is distressingly wrong, but the two female saints are so solidly, squarely kneeling and sitting on themselves that one feels pretty reassured. The landscape also slopes upwards badly. I notice that to rectify this fact I naturally lean my eye on the parapet, correct it by flattening it (such

corrections being automatic is a curious fact in art), and having flattened it in my sensations, that landscape thereby becomes walkable"

*

* *

A visit to Paris, in April 1902, gave me several observations on the *movement represented in a picture*.

Louvre. Prud'hon's *Cain and Abel*. "In looking at this picture (full of good-looking people) I notice that I never succeed in constructing anything in it, not even the dead body. I try to go into it, but doing so I am arrested by the fact that the people, although not projecting from the picture—although well behind the frame—*are still in front of what my eye claims as the picture*. And I cannot get round them into the landscape from which they are separated by a very real space filled with the visible air of moonlight, and every time I look there they *are doing it*. Cain always in the act of running—actively in the act—the avenging ladies always in the act of outstretching, flying, doing it! No amount of looking makes me a bit more familiar. I always find a little shock of surprise at finding them at it again.

"Similarly the little Prud'hon singer is always tilting up his head, always blowing out his nostrils, squeezing his eyes: always catching my eye with his rather hypnotising little presence; and I get vexed.

"Is it a mood of mine? But I find Madame Beauharnais also oddly doing her movement—slipping, propping

every time I look; and the branches of the trees also *do* their thrusts."

Resuming my observations on *rhythmic obsession*, the rhythm and movement in the lines of a picture; with indication of my perceptive and aesthetic condition.

December 7, 1902. *Uffizi Gallery, Florence.* "I walk along and having got to the top of the stairs and into the gallery find myself with slight palpitations, some sense of hurry and a tune—the Allegro of Beethoven's Symphony in D major. Accidentally I alight before Piero di Cosimo's *Andromeda*, and find it utterly impossible to look at while that tune (come spontaneously), and sense of hurry, last. I remember someone saying it is an early Leonardo, and I cling to it by this question. Gradually examining, from this point of view, I get *en rapport*, though rather with fragments than with the whole. (N.B.—While I am writing this and *not* looking, that tune has come back but no sense of haste.) I certainly see much better if I get rid of that tune. It slackens all the movement of the picture, which, when the tune isn't there (back while writing again), is astonishingly rapid.

"By rapid movement I mean that, e.g., Perseus is advancing through the air, wheeling round on himself when on the monster, back with great though perfectly deliberate swiftness. The little crowd of rather ridiculous people is also gathering very swiftly round Perseus, and is moving with swiftness—almost suddenness. The people doing nothing with musical instruments, and those weeping on the ground are also very *swift*. I suppose I mean that

their movement looks as if it were transient and new? Of course all these people are making gestures which are *transitory*, even poor tied-up Andromeda is bending quickly away from the snorting monster, and the two naked deplorables, weeping in each other's arms, could not remain long. The tiny figures in the extreme background (and these are probably crucial) are all hurrying.

"It makes the picture *interesting* but fatiguing. There is a mountain, by the way, rearing very literally, with its top going to overbalance it the next minute The picture, which I have always shied off, is rather crazy, quite independent of the monster.

"*Unfinished Leonardo*. Totally different impression (the tune distinctly irrelevant and out of measure). This is swift; in fact some things—the raised hand, the gesture of the king screening his eyes—wonderfully so, and the reaching-out arm of the child. But there is absolutely nothing transient. These people balance each other like the lines of a Gothic window. In fact the total effect is very Gothic: exciting, lucid, interesting and yet holding one.

"Above all the thing is a most complex *whole*. And these balanced movements will go on till Doomsday, and have always been there. It is the music of the spheres, the movement of the sun in the song of the Archangels in *Faust*

"Certainly I feel no tendency to mime any of them—in fact the more I look the less I can separate them.

"Returning to the ridiculous people in Piero di Cosimo, I certainly feel a very faint miming of his separate, very

separate figures. I can fancy the next twist of Perseus's waist and legs, and Andromeda, with her gesture of nausea, is rather disgusting.

"Leonardo (?), *Annunciation*. Certainly the tune has nothing to do here. I feel that the angel *has* a tune, but I can't find it. The staccato talking of the people all round is distinctly *out of time* (musical tempo) to the angel. The movement is swift, but marvellously *steady* in that kneeling angel, one of the loveliest of figures it now seems to me. It is the actual *time* (musical tempo) of his profile, of the wave of his hair, of the knots of his dress which is swift; something swift happens where the line of his eye meets that of his profile and his very faint eyebrow.

"The thing is in a way wonderfully passionate, in the sense of full of more than human life; but nothing could be quieter, humanly, than his greeting. Here, again, I feel that Gothic quality, but with more passion."

December 12. *Uffizi Gallery*. "Coming up the stairs (no palpitations) I discover a tune in my head and which I am actually singing or whistling. I think I discover it on saying 'I must look up the tune question.' It is Allegro of a Mozart Sonata. It goes on, and I suppose keeps pace with my a little accelerated heartbeat. I walk quickly and stop at the Baldovinetti *Madonna and Saints*. I know I like the picture and immediately get into a superficial examination. Pleasure comes suddenly with perception of bearded saint's white gloves. I then begin to see the relief, go *into* the picture. Light bad; I can't see whole well. Left-hand corner; I take pleasure in bearded man and much bulk pleasure in

Saint Lawrence and his very beautiful dress, and in his flat but solid existence. Am a little worried by his wrong spatial relation to bearded man Saint Anthony (though I *spotted* him at once, saying how like Baron A——F——) is difficult to look at, all because he is without solidity.

"In looking I have lost the tune, and I can't remember it. Another has arisen—something rudimentary I must have heard whistled in the street like a starling's song. I can't get it out of my mind while looking. A sort of raising of my hat and scalp and eyebrows seems necessary to see this picture; otherwise it is swimmy. By the way, the lilac and crimson give me a vivid cool pleasure, like *taste*.

"Cosimo Rosselli, *Magi*. The colour attracts me. I see it also less well when I don't raise hat and scalp. I can't just lay my eye on it. (Like Baldovinetti above eye level.) That street-bird tune goes on. I substitute a Chopin Mazurka. I think that makes it much worse I don't hate the picture, but merely because of its warm colour. The people are all stupid and vulgar. Flat as a wafer, and no going in, even in landscape. Why don't I hate it more?

"I simply *can't* and *won't* look at the 'Virtues' of the school of Pollaiuolo. I am stopped by an unknown Tuscan *Madonna and Child*. The resemblance of the Madonna to somebody at first repels, then attracts me. I am surprised to find this picture so good. Though I am a little worried by the child *doing* the *cuddling up*, and the *liking it*, too much and always over again (*à la Prud'hon*) and slowly; and I hate catching his eye. But the air and space please me The tune has subsided. It doesn't go with

the picture, nor the Chopin either. I know I shan't *remember* liking this.

"I am tired, can't go on, am bored with the succeeding pictures, as when one doesn't want to speak to people or be spoken to In looking out of the window there is the relief of not focusing. How out of time to the buildings, etc., to nature, all the people are walking. My idea of time is given by the delightful movement of ripple on the water, of fascinating colour. The people's talking also is out of time.

"*The Venetian Room*. I am tired, bored, disinclined to look at anything. The various paces, glances, the utter irrelevance of these wallfulls affects me like a crowd. I think a piece of pure colour would revive me (all this is dark and smoky).

"Yes, I can look with pleasure at Veronese's *Sophonisha*—even much pleasure, of which much I somehow know to be physical, located almost in my mouth. I do like this picture so much, although the two men with symmetrical repeated movement make me laugh and bore me. But the very idiocy, *the about nothing at all*, the indifference of executioner and executed, is pleasant. I make no scalp movement. I have a tune, a phrase of Mozart or Beethoven. It goes well—they seem to *say it*.

"Have I always tunes knocking about unbeknownst?

"Titian's *Flora* takes me. Her glance, gesture, drapery, all drags one in. I have no desire to stroke, touch or kiss, but there is a delight of life, of clean, warm life, such as one wishes for oneself in her flesh. Somehow she is

physically attractive—no, if her head were tilted she wouldn't be. The previous Beethoven or Mozart phrase interrupts her. Why have I the same pleasure, as just now looking into the river? She attracts me like that water."

December 18. *Uffizi Gallery*. "Already in the loggia below, a tune, I think a bit of a Beethoven Symphony. Arrive upstairs quickly—a little palpitation, but tune still there. (N.B.—It is not produced by the coming up, nor by the palpitations.) Absence of light in the Tribuna bores me, and I am unwilling to look at anything. I find that habit makes me attempt Titian's *Venus* (with room and figures in background). Tune going on hard, and distinct palpitations. The first thing I can look at without effort (initial effort excepted) is background. I go to the window; the pillar, pots, tree outside attract me. I do not care about the women, though the red one is pleasant. Perhaps I am trying through that window to escape out of the picture? I cannot go back without effort to *Venus* herself, and give it up. No! For wide-opening of the eyes and lifting of the scalp or hat (I have glasses, not spectacles) and breathing hard through my nose and mouth enable me to see her at last. But the effort is too great."

*

* *

"I go to the Leonardo (?) *Annunciation*, with a distinct emotion of expectant liking. And as a result, perhaps, am pleased at once. (I have liked associatively the cypresses

and landscape for years.) I go into the background, then cypresses, and return at once to the angel.

"That tune is now far too *slow*. I can look and enjoy breathing naturally, without effort, walking about in the picture in a leisurely spirit. I shy off the Madonna because (1) it is impossible, except at a great distance, to see both her and angel; (2) because of wall which I hate; (3) raw colour. I retreat to middle of the room—see the whole—Wonder, miracle! The Madonna becomes the magnificent other half of the phrase, and angel and Madonna after all go at harmonious pace. Or paces? or perhaps the cypresses hold one? But the *tempo* is very rapid, even in cypress tops.

"This is by a great, great man, but a very *long-sighted one*, for the wall gets into perspective only when I am halfway through room. This matter of long-sightedness might be a crass mechanical test of authorship. This picture, even from where the detail (dark day helping) is lost, is enchanting.

"The *Annunciation* opposite is certainly by Botticelli (it has been attributed to Raffaellino del Garbo, I believe). Here there is, besides rapidity, *suddenness*; and of course anatomically, the gestures are most unstable and momentary. But none of the Prud'hon feeling (i.e., of sudden repeated motions). The angel may dump onto his knees, and the Madonna may wheel round, like the people on Keats's Grecian urn,[1] forever, for they are doing it at the same pace. And the tree gives the needed sense of vertical."

1 "Fair youth, beneath the trees, thou canst not leave
 Thy song, nor ever can those trees be bare;
 Bold Lover, never, never canst thou kiss
 Though winning near the goal—yet do not grieve;
 She cannot fade, though thou hast not thy bliss,
 For ever wilt thou love, and she be fair!"

*

* *

"No wonder all art criticism is wrong, when we stand against a rail and look down into our pockets or up under the brim of our hats! Of course a great picture, like that Leonardo, is made to be seen at several goes. You possess the whole; but you also possess these exquisite details. These things are made for leisurely living with, not to make *one* bang! impression with a visual image banged into your brain like a seal on wax. This question of *bang* impression comes in, I fancy, with things like the Sistine Chapel, where, obviously, you *cannot* get nearer. How utterly have we separated art from living life!"

December 24. *Renaissance Sculpture in the Bargello*. "(I have come to verify a theory that the heads by Donatello seem to have more the feeling of breath in the nostrils than those attributed to Desiderio da Settignano.) I find I carry a tune—a phrase of Cimarosa's, which certainly does not go with the *Gattamelata* or Donatello's *Saint John*. The latter I find gets living, all except his leg. There seems an extraordinary rapid life, a deal of pressure."

January 19. *Uffizi Gallery*. "Arrive with hurry and fluster of great cold. A tune, scarcely more than a a 1, 2, 3, 4 rhythm (I think a Symphony of Haydn) already in arcade. It continues upstairs, and I enter with considerable palpitations. Am attracted by splendid gold dress in small Ignoto Toscano (Sienese). Look at it easily all except very opaque repainted robe of Madonna and draperies.

"The rhythm is here, but diminished. I get bored. On the whole I care to look only at the gold parts, and am much attracted by that same garment I feel the attraction of fretted, patterned gold and dark colour. Tune has suddenly changed; still 4 time; a bit of a symphonic cadence. It is so far from produced by a very poor blue Lorenzetti that I have to suspend its internal performance to see that picture. I try various other tunes, *all* make looking more difficult. The picture is singularly *out of time*, the eyes violently squinting in various directions.

"The splendour of the Simone Martini, seen (for the first time) from the opposite side (as probably intended), so that the eye, instead of focusing faces, goes into that golden sky, makes me literally gasp.

"Without my glasses, from some distance, this glory is still greater; to me enthralling. It is a question not merely of gold but of the *aliveness* of the sharp, acute, narrow, arrow-shaped silhouettes, of the flaming, sharp cusps and finials of frame (the sharp, sharp glory of angels—swallowtails extended, the spiny, rapid lines of the vase).

"It seems to me I have rarely had such a feeling of rapid flame-like movement. *It seems* to me that the feeling is

as if that glory of angels, that frame, really had motion as flame has.[1]

"What I can't understand is that a tune which seems a little dull (but perhaps leads to something whirly, I think) goes on every time I lift my eyes off that picture. Slight palpitations, at least rapid breathing with shut mouth. I am bound to say I have such a feeling of excitement that the arabesques of the ceiling, when I *take my eyes* off the picture, seem in movement. A man walks by very fast with creaking boots—his movement is *slow* comparatively; other people pass *quickly*, but slow compared to that picture. The exhilarating rapidity is, I think, the same as inside a good French Cathedral, Gothic.

"I look at Athlete with a pot, a fine antique decidedly, he is slower than the Martini and its frame, but much quicker than the people going quickly by. I walk twenty yards at a medium steady pace and stop before Doryphoros. I am astonished to find that he is not markedly much slower than the Martini. I keep the same tune.

"A bad Roman bust next to him jerks up, and I feel is *much, much* quicker—out of step to everything, including the tune. But he is out of step in a series of jerks. A man walks quickly past. But nevertheless he is slower than Doryphoros, perhaps because he walks *across my eye*; I don't follow him. Whereas in fact compared with Doryphoros I have no feeling of activity connected with him. I note the very immediate and great pleasure of those two antiques. Has the Martini helped me into them? Very bright day."

January 19. *Same day*. "Looking at the people in the Piazza del Duomo while waiting in the rubber shop, it struck me that the *movement* we perceive in them (and in horses, etc.) is of a totally different category from that we feel in works of art. All our ideas of swiftness are relative and in a way conventional; a man or horse is going quickly *for* a man or horse. But there is no *feeling* of swiftness. It is rather like a judgment—'This man or horse *must* be moving quickly to have passed across our eye (or a given space) in so much time.' There is no *sense of motion*. The only thing that gave it me was the vibrating movement of the pigeons rising and the rotating of wheels. Why?"

January 26. *Uffizi Gallery*. "Walking along, a bit of a Haydn Minuet—goes on although different with quick stairs ascent. Good light but general disinclination, I walk rapidly down corridor, worried by stiff legs of statues and goggle eyes of tapestry. Stop at Bellini's *Allegory*. This picture hangs too low. Consequently the floor always remains under my eye, and feels as if under my chest.

"It seems odd that a painted floor being lower gives less the sense of being under the feet, showing that we locate our feet in our eye. I sit down so as to be a little lower. Even now, however, I do not use the floor patterns to go in by. I go in about middle, just above people's heads. I follow the water (which as yet does not affect me as water) in the background and *there* look about me, houses, rocks, skies. Then I come back, so to speak, to myself, and look at middle distance, cavern, Centaur on

the other side of the water. It is only after this that I can look at foreground and figures and find it totally impossible to consider that foreground as a whole. Nor can I satisfactorily look at any figures or group long, although each is distinctly *outlined* and pleasant. I am worried as in watching aimless billiard balls.

"The floor isn't quite right under the people's feet. Those who are not leaning on the rail look as if they must be pinned on to keep straight. The children affect me as fastened in grooves; they could assume no other position on that floor. It feels easier for one to walk on that water than on that floor. I take it that we go to the floor or ground only after exploring background, because we habitually explore the back and middle distance, not the ground under us.

"When I stand quite close to the picture it becomes wonderfully agreeable. I utterly neglect that floor—or rather, in some funny way, it gets into position and I only vaguely feel it. The foreground figures, seen from above, balloon fashion, become all right. The sensation is that of looking from a balcony. The water reflections, village behind, sky, become the essential. The floor under the children is now *quite flat*.

"Veronese's *Esther* hangs high and right. I go straight up the *train* of Esther's lady, catching Ahasuerus in red stooping alongside, and am attracted into the open sky above parapet. The two men leaning down seem to give one leave to go to that sky, while with their leaning prevent one's neglecting Esther, etc. *The exact hanging of the*

pictures evidently affects enormously our manner, quite apart from degree, of seeing them.

"The *Mantegna Triptych* is hung too low. It must have been on an altar. It is annoying to have the Magi coming downhill into the region of the pit of one's stomach. If one stoops and thus raises the picture, the procession carries the eye *up*, instead of down It is clearly the artist's treatment which makes us consider part as below us"

1 Cf. p. 110.

*

* *

The subjective, introspective character of my Gallery Notes increases more and more. My aesthetic observations, interrupted in February 1903, by the sudden death of a very dear friend, were resumed in Rome in April, when I was in a state of nervous collapse, and subject to very strong alternations of feeling. This circumstance led to my giving a maximum of attention to the variations in my own aesthetic receptivity.

April 7, 1903. *Rome. Terme Museum*. "Effect of *emotional tone* on aesthetic perception. The other day, the first time here (but it was pouring, the light extremely bad and the rooms were most inconveniently crowded), feeling fearfully depressed, the lid down on life, *but not in the least preoccupied*; on the contrary, listless. I not only

did not feel, but I didn't see 'how beautiful they are.' Nothing caught my eye.

"Today, rather tired in body and spirit, but extraordinarily shaken up, (very literally) warmed, vibrating through and through (most literally almost quaking) with yesterday's very strange experience; moreover in the complete grip, obsession thereof (thinking it perpetually backwards and forwards), but also immensely heightened in self-confidence; I find I see very easily, even quite slight things, and feel and vibrate to the movement of them—the swing round of the Niobid, etc. A slight but perceptible state of palpitation, rapid breathing through the nostrils, no sort of distraction or worry from without (perfect sense of freedom from others)—a bit of Bach humming in me. The day perfectly fine, cold, tramontana, light excellent."

The rest of that day I suffered from a reaction from physical lassitude and mental depression.

April 10. *Capitoline Museum*. "A tune, mainly accompaniment, of *Phyllis* (old French song), on entering, and keeps on. First room I enter (Hall of Nero Antico Centaurs) quite intolerable; impression of gibbering. The statues seem infinitely more intrusive than the moving crowd of tourists; all agog, gesticulating idiotically, a bedlam. Is it that I have become abnormally sensitive to movement? Out of the window Marcus Aurelius even seems to be going unpleasantly fast, distinctly out of time to the architecture. (Slight palpitations, a slight but rather pleasant excitement all morning, perfect lucidity.)

"In the room of *Gladiator* I am arrested, and have a moment of vivid pleasure before the griffin tripod near the window. Griffins have the intense, vivid rhythm of flame. After a little their horrid stiff bodies and legs begin to bother me. And I begin to catch the eye of one rather too much. There is too much emphasis, decidedly.

"By this time, and thanks to the griffins, I am *en rapport* with things. *Gladiator*, for instance. But oddly enough I experience him as a little too quick, a little too exciting in time: the knots of his hair jump out a little too much.

"I have very marked palpitations, and I suspect that the overperception of movement is a summation. Oddly the vague, shifting, gravityless movements (if such they can be called) of the crowd do not worry me: they are like ghosts compared with the statues and me.

"Window. Even the opposite architecture—heaven help it!—is a little bit exciting, and Marcus Aurelius, seen a little back, is thrusting that arm a little more than is pleasant. The people, cabs, etc., in the square, on the other hand, though hurrying for the most part, have no movement I can find.

"All this seems to shed a light on *Einfühlung*, does it not? The work of art made exciting to me by my own excitement, the reality remaining utterly unreal, passive.

"*Big Hall*. Again of course it is the beastly restorations largely which make these statues gibber. Also, their being quite remarkably bad In my present state of excitement (palpitations continuing) it seems to be the gesture

of the bad statues which hustles and worries me, and the time of the good ones. Yet even the bad ones, dead as doornails in line and mass, how infinitely more living and moving than the real people. To add a gesture to a statue is like adding squibs and crackers to already existing music. If real people had no gesture, they would have nothing, be nothing, save to very careful and loving eyes."

April 15. *Terme Museum*. *Subiaco Niobid*. "(Fine day, soon after lunch, very good spirits, state of happy, not at all impatient expectancy. Very slight palpitations from walking rapidly and stairs, only running as a faint rapidity of life, unlocalised, breathing through nose, mouth shut.) I see very well, easily, have no sense of *seeing*, but a strong, full sense of *it* (the *Niobid*). *It* is the only nominative. Despite the bad architectural building-up the figure is delightful. It seems to be swinging about, thrusting forwards, pressing down, hurling up, with a total delightful spiral movement. Oddly this impression is irrespective of the point of view, and exists equally in that total impression. I take it the total impression is one of pushes and pulls and of this unstable equilibrium, which has the same exciting intellectual quality as good Gothic. I am perfectly aware of the remarkable ugliness of the line in many positions.

"The pleasure seems to be in the impetuosity of that spiral cast forwards of the body. Still, I do not think there is a vestige of pleasure in anything human: I am familiar with such impressions about landscape. The surface modelling and patina give me another kind of pleasure,

like that of the chest of Titian's *Flora*. I find nothing human in this either, for I am conscious of a negative satisfaction in this surface having no tactile softness and no temperature; the fact of the bystanders having both is on the whole repulsive to me.

"Looking at them I realise how utterly the *movement* of this is different: it is not so much an infinitely greater life, spring, thrust, *weight* (weight particularly), but a different one. One wonders how or why the real people do anything: they seem to stand on the principle of inflated paper bags or eggshells on end.

"*Apollo* (Pheidian). How *he* erects himself. But without excitement; it is like the interior of, say, Cappella Pazzi! And he, poor dear, with half a skin too little,[1] is yet absolutely satisfactory. It is a question of pressure, of splendid cupola-like lifting.

"Leaning on balustrade of terrace outside I get him at a better angle and distance. I get him particularly in the midst of *my* impressions of air, of stirring leaves, flying, chirping birds, children playing outside. He is in my life.

"I find I have now a different tune from the one I came with—it is the *ritournelle* of the end of *Divinités du Styx* of Gluck. Is it a subconscious association of ideas— Apollo, etc.? For some time I could not identify that tune. Also, though those bars seem to concentrate my seeing of him, the opening bars distinctly improve it.

"Even that brute of a sitting Athlete has an attractiveness in his mountain quality, when one gets his head in profile—the *rise* of the head and *fall* of the shoulders.

"*Cast of Ara Pacis*. There is a great deal too much looking out and about, and this group of toga'd magnificoes is distinctly going at various paces and not in the same direction; their arms grab and hang loose with wonderful motion and irrelevance"

The introspection henceforth becomes habitual and deliberate, and is extended to one detail after another.

Venice, October 9, 1903. *Academy*. "Cool northwest wind after rain; feel much better, almost braced and relieved, pleased at having come to a difficult resolution. Very pleased also at finding A—— below, and relieved about her ill friend, and idea that I may be useful. Rubbed the wrong way in gondola by some mannerless tourists. Attempt at showing them anything frustrated. Find myself with strong palpitations, a general sense of cat's fur brushed the wrong way. And a tune—I don't know what—apparently bit of symphony, beating itself out inside me.

"Great difficulty, as usual in this gallery, in seeing anything. So far I have *seen* nothing—not a scrap better than my companions.

"I have vainly attempted to see the *Dives and Lazarus* (by Bonifazio). After three or four minutes I begin to see it, attracted principally by the colour. Another vague look at the people in it. The mental irritation diminishes (have got rid of tourists), but the palpitations continue and the tiresome, tiresome emphatic tune. Get up and look into picture nearer. Palpitations still very disagreeable. Great desire to see the picture, and utter impossibility to do so. Distracted and bothered by sense of futility of this whole

morning. After some minutes still much the same. I cannot comfortably see the foreground. I feel sure some perspective arrangement makes it difficult to see these very attractive people. I find I am beginning to care for background—all beyond the empty middle of picture. The little altar (which I had never noticed) or Three Graces fountain, and man with bow and spear (?) and dog begins to attract my curiosity and to charm me.

"The dog is greedily thrusting his head into the fountain, climbing energetically on his hind legs, the boy has a sort of lyric, passionate flutter, as if adoring the fountain or the figures. A thought of Hippolytus, scraps of the invocation to Artemis, or at least a *feel* of it, arise in me. It is significant that I am caught by the literary sentimental sight. I *like* it, enjoy it, go with eye into the *charmille* of garden, and begin to feel considerable reluctance at leaving the picture and looking for my companions, which I suppose I must. By this time I can look at foreground, *feel* the charming people. Palpitations still. But that beastly tune gone—and instead, oh joy! a bit of an accompaniment of Brahms: *Wie ist doch die Welt so schön*."

October 11. "Cloudy but cold morning, bracing. Walk quickly to Saint Mark's, feeling tall and light, and quietly happy. Had suffered lately from distraction, *aridity*, impossibility of seeing art—seeing the people too much. Surprise at walking into comparative dark, *I go into it*, and *into the organ music during the Elevation*. During that music I see and feel. The central cupola is, indeed, revealed

to me the first time. Slight palpitation: *I had no tune*. The organ's tune became mine, and the church lived to it. Ten minutes of very concentrated feeling, perfect.

"Same day. *Ducal Palace*. I clap on to *Bacchus and Ariadne*, see it immediately; that deep, deep blue; I linger, pleased, unwilling to leave. (I was unwilling to leave Saint Mark's also.) I was aware of no tune before, but as soon as I see this I am aware strongly of a theme—I think out of Beethoven, the Seventh Symphony, with which I see this—a sort of waltz tune.

"Same for *Three Graces*, but this picture takes me a little less. I do not notice the tourists, but when they thrust into my attention, I feel violent annoyance at voice or gesture, as at a fly when playing or reading.

"*Sharp* pleasure at the little poppy-pod lanterns on Saint Mark's cupolas, and at downward line of cupolas. The pleasure seems to have the sharp, crisp, puckered quality of those lanterns. All these cupolas, at least the three I see from the window, are unlike in the clustering of those lanterns and rosettes.

"Loveliness of opal white grey of lead and Istrian stone—moonstone colour—against white, luminous, delicately cloudy (*not* scirocco) sky.

"As usual, in the inferior pictures of the Ducal Palace I am bothered by the sense of the people, their expression, gesture, personality; they are all doing things and in an absurd way—poking out their hands, flying I said a true thing at the Academy, when we all fell to finding likeness to acquaintances in (of all painters) Rosalba!

When we find strong resemblance in a picture it is that the picture doesn't exist, or our attention doesn't—only the acquaintances exist. I make an exception in case of loving people. We often find in some very fine work of art a resemblance to some beloved one; but it is rather a state of our *feeling, a going-out* of it, and the masterpiece remains, never overlaid by the reality, but rather magnifying it, as sudden music magnifies our emotional state."

1 One side of thorax abraded by water.

*

* *

At Florence in the winter of 1903–4, I resumed my observations in the museums with especial reference to *rhythmic obsessions*, palpitations and aesthetic responsiveness.

December 30. *Uffizi Gallery*. "Cold, wet day, feeling well. Drive; and have a tune coming along. Can't identify it. Palpitations from staircase. Weak glasses and bad light. *Martini*. The tune doesn't answer. The gold attracts me, but I have difficulty in being interested. Shy off Virgin. (Tune continues while writing.) Angel's wing attracts me, and olive branch. Get a little interested in wings. They come into singular relief. The tune while looking at them diminishes, but regains while writing. Still palpitations Try quick Bach. No. The forward head of angel interferes somehow with my tunes. See Athlete with vase at once and well."

*

* *

January 7, 1904. *Uffizi Gallery*. "Fine, dry, sunny day. Drive. Slight mental irritation and dissatisfaction in portico; march time, no palpitations, but slight feeling of chill. Unwillingness to look. *Venetian Room*. I single out, attracted by light colour (lilac, stone colour, scarlet) among all these sunk in blackness, Veronese's *Esther*."

*

* *

"*Duke of Urbino*. Taken by crimson velvet, by splendid slick painting, silveriness of armour and the man's disagreeable face. I stick in the picture, nearest approach to pleasure. The tune (which I revive, for it subsides when I look) does not suit.

"I think I am preoccupied by dissatisfaction with my morning's work. Another rather similar trivial tune, but different rhythm. It seems to help me to see the small Bordone head. I *realise* skin, hair, eyebrows and the Miss C—— physique of the creature."

*

* *

"Titian's *Flora*. I try to go in by pleasure—tactile, thermic—at her flesh and skin, and the vague likeness to a friend

I am very fond of. I get to like her—the silky fur quality of her hair, and her brows. I wish her eyes were deeper and am annoyed by lack of modelling of her cheeks. The insufficiency of her *humanity* seems to bore me. It isn't enough to be such an animal or fruit. But there is an interesting synthesis of form and subject; specially of the sense of bodily cleanness, soundness and healthy fresh warmth. Yet I do not feel any particular desire to touch or squeeze her; she is still a picture, a goddess, not a cat or baby

"The trivial tune has subsided. If I keep it up, I have to slacken it greatly. This is the day of trivial tunes—a Spanish one comes up. She looks calmly, decidedly *away* from it.

"The lullaby of the Christmas Oratorio which I, casting about, revive, seems to help me, to make me see her more as a whole, *circularly*, to get depth of glance, not to think about softness or warmth, etc. She seems to get a soul. Though wretchedly cold, I am beginning to be interested and pleased.

"That Christmas tune has no effect on the Bassano *Burning Bush*. I am too cold, shivery, and must leave this room."

*

* *

January 28. *Cappella Pazzi*. "Fine day, good spirits. But the falseness of our modern art habits! Having nothing

to do but to look at this place (and to look without any definite object) I find myself in continual state of distraction, thinking of, attending to, everything else, painfully trying to steady my thoughts. *Whereas it is the Chapel which should be acting as interlude* to whatever I am doing. Oddly confirming this as soon as I begin writing this note; my attention steadied, I feel the attraction of the place, begin to be in it and unwilling to go out."

Same day. *Uffizi Gallery*. "Pleased to get out after a boring lunch and blood to head. Light step; under arcade a tune—*Ich will dich mein Jesus*, by Bach. No palpitations; go into *painters' portraits* room to see whether Sargent's is there. Look about interested in purely personal way; tune continues strong. Not tempted to look at anything much. Attracted by *Benjamin Constant*, but tune prevents my seeing it. But I can see *Ingres* very well. What a deep, deep magnificent picture. The tune, if anything, helps certainly; and this picture of a quiet man is, like my tune, decidedly exciting (slight palpitations beginning, and breathing with closed mouth). The picture is so interesting I do not even care to spell out inscription in corner; am riveted by the eyes and mouth.

"*Cabanel* goes to bits—dissolves to soapsuds to that tune.

"*Leighton*, I cannot see as a picture. Keep spotting likenesses, my father, etc. The tune prevents and makes the frieze cavalcade in Leighton's background go out of time. (The tune seems not to go with the palpitations, which increase, and I have to keep it up artificially.)

"*Millais* fairly well. *Watts* fairly well, with some effort to keep up the tune.

"*Morelli*, *Ussi*, *Zorn*, *Baldini*, etc., utterly incompatible with the tune.

"*Herkomer*, already grotesque, becomes under that tune a sort of *pulling-out* doll, a goggle joke.

"*Zorn* keeps walking out of the canvas under that tune. Most of these portraits are oddly staring. *Tadema* is the real winking human being; he gets mitigated by the tune, but also disappears under it.

"*Villegas*, easy and agreeable to see (not gibbering and well under his frame), is better without the tune. These portraits are most horribly *speaking*.

"Return to *Ingres*. He has a little lost his hold over me, I suppose by the confusion. But regains it with tune slower. Palpitations distinct. Upstairs. Tune continued, partly voluntarily. I can't see with It the Simone Martini at all But the gold blinds me in this very strong light. I try five or six other tunes, no good. A slight improvement on *Stabat* fugue, but still little. Perhaps it is mere prolonged attention. What I do see best is the angel's wing. I go nearer it to see. I fix angel's wonderful crown and olive branch. None of that fugue nor Bach. It seems to overpower—*I cieli immensi*—'For unto us'—a near approach at last! First movement of G minor Mozart Symphony; *it* makes the thing go tearing pace, and the thing makes *it* go quicker.

"Surprise at seeing Leonardo Cartoon in light. Bach does not fit."

February 6. *Uffizi Gallery*. "(I have been a little unwell lately with dyspepsia and insomnia; and besides, mentally worried.)

"Rainy, warm; but good spirits and amused. Arrive with theme immediately preceding the Minuet of *Don Giovanni*. No palpitations."

*

* *

"*Sort of Apoxyomenos*. How the restorations make it all go at different paces. The preoccupation (now spontaneous) of that G minor motive makes Baldovinetti's *Annunciation* fall to pieces and the angel and cypresses go various paces Extremely distracted, noticing (without annoyance) steps and talking, and struck by likenesses. Shall be glad to go and was unwilling to come. Have just met twice a person with whom I had quarrelled. Am feeling very personal, and what I should like would be a good solitary country walk.

"Eye and curiosity caught by absurd gesticulations of little stories of *Esther*. I am attracted by the story, the people The G minor theme goes on irrelevantly and excitedly.

"*School of Cosimo Rosselli*. Am caught by rug, hot colour and vehemently craning Jewish angels I am tired, *distraite* and impatiently waiting for cart."

February 27. *Vatican Museum*. "Am depressed, distinctly sore about the breastbone with the bodily sense

of misunderstanding. I find in these statues (which I see at once and quite well) an extraordinary calm, charm, some sort of deep kinship and confidence, which comes out to meet my perfect goodwill, my determination not to let the passing hours be wasted, the beautiful present of life soiled by personal sadness.

"This time, being with friends, neither in the faintest degree inclined to look at anything, I strolled about wholly unprofessionally and thinking about other things. Oddly (and yet my theories might have led me to expect this) I was able to see very well in the intervals of our desultory talk; they seemed to catch my eye, in a way to beckon to me. The interest was a very full and composite one, in which while *thinking* of the statues as people (nay friends) I *felt* them very deeply as form. This is evidently the normal process."

*

* *

March 8. *Interior of Saint Peter's, Rome*. "In Saint Peter's (towards dusk) if I *feel* tall and lightly balanced it is because I actually *am* so; the muscular objective fact precedes the feeling and is due, obviously, to the way the eye is attracted to a high or very distant part, and the step and balance, the whole tensions, are determined by this necessity. Coming out onto the steps, I feel an immediate possibility of walking more or less hunched up. The greatness of the place had taken me and quite

unexpectedly at once: the pale shimmer of the marble and the gold, the little encampment of yellow lights ever so far off, close to the ground at the Confession; and above all the spaciousness, vast airiness and emptiness, which seem in a way to be rather a mode of myself than a quality of the place."

March 9. *Vatican Rooms.* "Fine windy day, painful circumstances but deadened; slight bronchitis. Arrive in Stanze after easy strong ascent of stairs, palpitations from it. I find I have, very discontinuously, the final cadence of Caccini's *Amarilli*, heard yesterday.

"*Parnassus.* I don't go in very easily; the voices and shuffling disturb me. The *Amarilli* continues and I am bored and distracted. The heat and closeness worry me. The people attract my attention. I *yield* to this state, and go on and observe people. I go into Sala di Costantino and return to *Heliodorus*. When I think of it, *Amarilli* cadences. *Distraction* continues. I am struck by defects of *Heliodorus*. The *out of plane* of angels' corner proved too much, and so the grotesque and disgusting, grimacing people near Heliodorus. I have extreme difficulty in going into where the high priest kneels, and yet it attracts me, or at least I wish it. Cross light intrudes. The gestures of the people affect me as overreal and sudden. The fact is that my wandering attention assimilates all it catches with reality.

"Ceiling—everything strikes me as overquick, almost spasmodic—the flames of the bush as much as God the Father.

"*Liberation of Saint Peter*. A bothering amount of emphasis, gesticulation, realism, something *stereoscopic*.

"Having met a friend, I proceed upstairs in hopes of Melozzo da Forlì.[1] The tune has changed to a mere seesaw—minor third downwards.

"I am surprised by the beauty of Melozzo's colour. But the figures even here seem disagreeably projecting—flattened, yes, but still projecting. I long to push them back and deepen the background. The steps and voices, creaking boots affect me painfully. Evidently I am in an *aggressible* humour. The custodian pulls out Melozzo and with the right light, a miracle! all goes into its place, and *I* into it. I see it then quietly, though not intensely, till it is turned away.

"I find a certain relief, pleasure, in a very deep seagreen Perugino background (picture in a good light). I seem to free myself from these visitors. But I don't care for the figures, which again strike me as too salient. The darkness of the great blackened Titian attracts me, but merely as a dark room might, the figures bore me, and seem grotesque I believe the bad air is acting on a slight bronchitis oppression. I do not breathe easily.

"Other Perugino, *Four Saints*. The temple perspective and green background please me, but the people seem real, stereoscopic and *posing*. I take pleasure in the few inches of free foreground in front of their feet. I am not exactly bored or in a hurry to get away.

"*Transfiguration*. The hot, emphatic colour! I catch sight of nothing but *hands*; there seem more hands and

feet than people, and such vulgar curiosity, pointing, craning, staring—faugh! I am attracted by three small *Saints* by Perugino, and with upturned eyes am looking down blank, dark background. It gives me a sense of rest and silence. Decent people, allowing me to live."

1 I.e., Melozzo da Forlì's fresco of Sixtus IV and his nephews. It was at that time still upstairs.

*

* *

March 14. *San Pietro in Vincoli*. "Fine *tramontana* day. Am a little better pleased with life. After ascending the steep steps I go into the church, very decidedly thinking of other things. Over the back of a Cook's touring party I catch sight of *Moses* (by Michelangelo), head and shoulders, and am *immediately* impressed by his grandeur. The Cook party having gone, I sit down quietly before Moses, by no means determined to see him. (What I wanted was the walk and the sense of having been there.) I see him well at once, quite unimpeded by the incongruous monument, and not at all worried by the people. I did not even *see* the Cook's party as they stood close.

"My attention goes slowly, regularly and easily from this book to the Moses. I take my chair to the other side, and see his full face equally well. But it is an intermittent attention. I return to my thoughts, go to him, etc. This is much the way in which today, with great enjoyment, I heard Miss C——play some Chopin."

*

* *

"*Portrait of Innocent X*. How Velázquez has taken trouble, by slightly placing the chair and sitter askew, that we should feel, *as he does, the other unseen side*, the fact that the man and chair have bulk.

"This, I believe to result psychologically from the intensity, vividness and completeness of the great artist's *feeling* of what he sees (i.e., richness of accompanying memory images giving explanation of nonoptical detail). But the pleasurableness to us depends, I think, mainly on this four-square quality making the eye go on, and preventing all sense of aggression by this humanly threatening individuality.

"If the chair were straight (no 'round-the-corner' indicated) and the man perfectly straight in it, we should feel that this Pope (who has only a curtain, though skilfully folded tent-like, behind him) was infringing on our life, instead of adding a region for exploration and contemplation to it It is odd how piercing the glance of this Pope is, and yet I have no sense of aggression or of indiscreet personality.

"The collar, the circular cape and cap somehow turn him into something vitally unhuman, a great magnificent peony, with those odd eyes looking out of its depths."

*

* *

The following entry gives a singularly typical example of dynamic *Einfühlung*, and as such I have used it and referred to it elsewhere.

April 29. *Florence*. "Yesterday I went into the Baptistery after taking Mlle. K—— to the station. Good spirits, but unwilling, and from mere sense of duty went into Baptistery. The place interested me so little, I felt so completely the hopelessness of such attempt to be interested, that I even began to read the newspaper as a sort of excuse for resting on a bench; the unsuccess of my aesthetic attempts (at enjoyment) being positively degrading. Walking about, my eye caught that swirl pattern.[1] I was immensely surprised that from a distance it took the appearance of a double trefoil. I approached; while approaching and while I stood quite still the pattern seemed to move very positively and violently; to *dap* up and down, swirl round and round, as I *remember* water does. I say *I remember*, because it is possible that by comparison with *real* water this would have been motionless—or the contrary? But the movement seemed to stay objective; I could trace no movement of my eye or attention. No work of art has ever given me such a positive sense of movement. I was not inclined to be interested, quite the reverse, and everything else seemed as dead as a doornail.

"I had been waiting at the station nearly an hour, noticing, *undergoing* the faces and manner and movement of the people with disagreeable vivacity. I did not notice about a tune. At Duomo after; not very receptive."

May 10. *Church of Santa Croce*. "Came in idly, while awaiting the hour to lunch with a friend. Find a tune in me while walking along here, the answer of Zerlina, *Mi fa pietà Masetto*, where it is repeated quickly, only *I* have made it into a slow 1-2-3-4. To my surprise I continue to have it before Desiderio's honeysuckle and palm pattern (*Tomb of Marsuppini*); only I take it quickly and with its natural flutter. Have had rheumatism, much nervous irritation and feel bored though not depressed after bicycling against high wind and walking. I felt no 'immersion' on entering church, and was interrupted by fumbling at entrance for penny for beggar. No sense of being enclosed. Little desire to see anything. The footsteps irritate me much. Have been worried by thought of people coming and interrupting me this afternoon. The beggar woman alongside of Desiderio tomb strikes me now much more than the tomb. The little boys on it seem pert. The tourists and guide worry me The tourists keep catching my eye, and seem moving very quickly. I sit down tired. My tendency is not to get absorbed in the place, but rather stupidly distracted, staring without seeing, or at least feeling, minimising sensation, as happens when I have to wait at a station. I want, however, to have a look at Donatello's *Annunciation*. Impossible Different tune; some Beethoven, First Symphony. Impossibility of seeing Donatello, though I want to. Both those tunes impossible. I will make an effort. There seems an actual ocular difficulty, want of light. I like staying simply from laziness. Still I am not dispirited,

only worried by constant cramp in hand; I have worked well and easily."

May 14. *Academy*. "Come on bicycle in heat, much jolted; veil has blinded me. Vague sense of pleasure at being among these pictures after a year or so. Impossibility of seeing big *Angelico*—the figures come out and there is no air behind them. I should like to go into background but can't. It is that puppet show coming forwards of figures. Palpitations I catch eye of figures disagreeably and they gesticulate so. The catching of eye is not due merely to lack of composition, they all actually roll their eyeball and grimace.

"I was *platonically* attracted from first by little Botticellis and resisted. I see little *Salome* at once most vividly, but the tune remaining (has it to do with palpitations?) intermittent with it. The other three little panels also seen at once and well (the comfort of a thing small enough to cover, isolate with one's eye!).

"That tune and the palpitations (the tune has a seesaw) seem to make a sort of pattern of excitement at certain beats of which I catch Botticelli well.

"The *Resurrection* (by Botticelli) seems less harrowing, tragic than I remembered it. I go in and feel so comfortable in it.

"But I do not feel inclination to linger, am restless.

"Tune and palpitations continue. Can't see big Gentile da Fabriano

"Botticelli's *Spring*. In an excellent light but with my palpitations full-cock, I see the *Primavera very* vividly,

almost hyperaesthetically, but piecemeal. The upward and circular movements become *actual* almost, a sense of lifting and turning—yet not gibbering, though the thing is so fearfully acute as action.

"Curtain closed and diminishing of vitality. I see less well *ocularly*. That seesaw bell tune goes on. I do not see the picture *on* it, but between, in a frame of it.

"I am tired and lean lazily against wall; when I catch *Primavera* it delights me. I rather like being in the same room and don't want to go away. Not the faintest inclination to look at other things.

"I seem to see it less well sitting, although glad to sit.

"Extraordinary look of irrelevance in other pictures, such posing. This *Primavera* is really a world of enchantment, and I fancy one remains in it even when not looking. One might experiment with some reading in its presence. Have read my note on a certain fountain with a most vivid feeling of being in the country. I come back quite easily and am at once taken by this picture—made to tread these mazes.

"Palpitations much fainter, but quiet heartbeating and always to that tune. I find myself able to see the small *Nativity* of Lippi, but not as a whole.

"That tune seems to give most absurd movement to Perugino's *Gethsemane*: the people seem to sway or roll like a ship."

Florence. May 24. "Hot evening after stormy day. I have come to town to meet a friend at station. But no excitement. Have been ill and very tired two days. State

of vague daydreams. Have walked from tram and shopped.

"*San Lorenzo*. No impression of enclosure in church, only of rather sweet fresh incense. People are like ghosts. I can make no effort to look. But Verrochio's fountain pleases me by the vivacity of lines. Nothing in it gibbers. I have very little sense of sacristy. I am not distracted by outer life, indeed scarcely perceive even *Cicerone*, but perceive nothing except splash of fountain, echo of evening service and that sweetness of incense and coolness. Everything is dreamlike. If it were the first time I might have an impression, but I am too sleepy. I am not thinking, I have bad headache on the way, sleepiness and kept on smelling smells.

"One of the bronze doors in a ray of low light suddenly catches me, and some fig leaves outside window. Making an effort to see merely makes me hear the talking priests and get bored. I begin to notice conversations a little. It is all very agreeable, but I am too sleepy. A curtain suddenly drawn (always in sacristy) and I awake a little. The frieze of terra-cotta cherubs seems to be making *battements*. It neither vexes nor pleases me. But that bronze door in the light pleases me. So agreeable not to wonder who and what the people are—mere shiny and shadowy surfaces. Pleasure at this as in moonlit garden when tired.

"Having tipped sacristan I linger. It is all so vaguely pleasant—fountain plashing, incense, echoing sounds, beams of light high up, coolness and I like the marble

table very much, with vestments and hats and Donatello tomb mysteriously tucked under it. I catch that glistening bronze gate again and a great stack of wax candles.

"This is really an enchanting form of sleepy impression if one could lie down instead of sitting on a hard bench, and if one hadn't the idea one *ought* to (but *won't*) look up into the cupola.

"Total indifference to tourists. It has cost me an effort to get out this book and write, but far less than to look at anything. How little trouble observing oneself and writing is. It seems part of the drowsiness."[2]

The extracts from my notebooks finish appropriately with this one, which shows how easily, without being in the least disturbed by it, I could note down my aesthetic conditions. For years all my psychic life has been thus accompanied by consciousness of itself: only logical thought, work, interested conversation and states of extreme emotion suppress the spectator, whom I carry within myself. The greatest aesthetic enjoyment, always very calm in my case, is accompanied, as has been seen, by a constant consciousness of my condition.

Having ended this series of observations taken down rapidly, I will ask leave of the psychologist to place before him certain other extracts from my notebooks which I have taken out of their chronological order. For these notes which follow contain, by pure chance, some of the main conclusions, some of the most striking hypotheses which have come to me in the course of these two years of intimate study of my own relations with works of art,

overthrowing or strengthening the aesthetic theories I held before.

They were made either in presence of the work of art, or always under the impression of it (within twenty-four hours).

They are, to tell the truth, merely the omitted synthesis which the reader has been able to gather from the preceding notes, a synthesis come spontaneously and without intention of examining the state of my theories.

These notes will, I believe, exempt me from making an examination of the results to be drawn from these studies, by indicating them in a spontaneous and natural way, corresponding to the direct character of my observations.

The first of these notes (December 17, 1901) will perhaps serve to make plain a point frequently alluded to in my notes: "the deciphering of the symbol or the subject," as opposed to the perception of the form; and to unite this artistic phenomenon with the daily act of recognising surrounding objects; an act of which, to tell the truth, psychology has, until now, not taken sufficient notice. This note deals with the phenomenon which, despite the explanations of Wundt and more recently of Lipps, writers continue to call "optical illusions."

"Looking down at the little farm just rebuilt in the valley below I saw, most distinctly, that the new shed, open towards us, on the bend of the stream, was filled with the splash of a mill wheel; and the water ran round quite rhythmically in great heavy white bubblings, fill-

ing the dark shed with its flash. I pointed it out to a friend, a painter, who saw it also. But, she said, almost immediately, 'I think it is the smoke out of the chimney in front.' (The chimney was halfway down the hill.) 'Nonsense,' I said, and continued to see the millrace in that shed for certainly three minutes; and shifting my place a little until I moved sufficiently for the curls of smoke to be visible against the side of the hill, when the shed became empty. But what made me finally believe that it was smoke was my friend pointing out that the movement of the water was towards the hill, i.e., backwards.

"The place is called *Mulinaccio*—Horrid old mill. I said to myself, 'They have turned it back into a mill.' And I had been looking the moment before at one of the tributaries of the stream Mensola rushing downhill opposite with most visible boilings like those of my supposed millrace; moreover, that wet day my mind was much impressed and delighted by the bubbling and seething of water everywhere."

This recalling of previous visual images by means of which we interpret forms seen by the eye is shown in a second note made on May 3, 1904:

"High above Igno, I look down on a very tall white tower outside Pistoia. It turns out to be a straight road. But every now and then I see it as a tower again, and then distinctly feel a third dimension behind it."

I would beg the psychologist to consider this second "optical illusion" together with my observations on the way in which we sometimes correct involuntarily the

defective perspective of a picture and, when we have once grasped the idea the artist wished to represent, we flatten, for example, vertical lines into what we judge to be a sheet of water because of reflections owing to its colour.

To this question of the part played by memory and judgment in the act of recognising real objects, or the artistic representations of real objects, there should be added my various observations on the subject of "real motion" (actual changing of place) and of the "movement" we attribute to lines.

The following note adds a more theoretic development:

April 1904. "I find an old note of my own, April 21, 1901, saying of antiques: 'They are not doing it, because great art does not give movement of people, but movement of lines and surfaces,' etc. I would now add that what in art is *movement of people* probably varies from artistic generation to generation, because *movement of people* is an inference we make, and because we make this inference on different degrees of suggestion. What may suggest movement (i.e., locomotion) to a Byzantine will suggest nothing but immobility to a Renaissance man; the Greeks probably felt attendant movement of people in the *Discobolus* as much as we do in Sargent, because they were equally looking for it. The more complex the formula of realism becomes, the less satisfied we are. A peasant thinks an oleograph *very like*, because he is not accustomed to something more like: he *spots* and infers more willingly than we. *Reality, real movement*, are in fact

equations between our powers of recognition and a symbol, and they are therefore shifting, for the symbol alters. But the equation between our aesthetic faculty and 'form' does not alter, because there is here no symbol."

1 This pattern is on the Baptistery floor, near the N. gate. A somewhat analogous, but quite *dynamically* inferior one exists (or existed!) in the old floor of Saint Mark's, Venice. An eighteenth-century engraving shows an exact but (at least in the reproduction) utterly spiritless Roman duplicate, existing, I think, at Nîmes. And my friend M. Emanuel Pontrémoli, who has done architectural archaeology and excavation in Asia Minor, tells me that the pattern is Graeco-Asiatic and possibly very old. The Baptistery floor is, I take it, of the late twelfth or early thirteenth century. Cf. also p. 87.

2 Edward Bradford Titchener, *Lectures on the Elementary Psychology of Feeling and Attention* (New York: Macmillan Company, 1908), pp. 179–180: "... the experience that I want to bring to your mind is this: that, as one is reading, one is able to take mental note of passages to be remembered and employed, without appreciable pause in the process of reading itself, and without even momentary loss of the thread of the writer's argument when we close the covers of a book ... we have marked down half-a-dozen passages for further use without interruption of the main current of consciousness. That is the technical, critical attitude; and the introspective attitude is akin to it."

*

* *

Portrait of a Lady Singing, by Sargent. "A picture gives *not* the value of the seen person or thing, but the *summation* of the person or thing seen, heard, felt, heard about. In this case this assemblage of lines (what would be the value of the mere assemblage of lines, could we separate it, of the real lady?) gives the value also of the lady's singing.

"The golden rule of art is not, as Lessing thought, to avoid representations of sudden, rapid, fleeting movements, but to make the representation of what we tolerated or were agitated by when thus sudden and fleeting, satisfying and interesting when permanent."

Development of the idea of movement and rhythm in art.

*

* *

"This smaller bronze room is really a Babel of people talking different tongues, vociferating. While for the most part, the details of a landscape, of a street, assume the vague character of natural noises which we scarcely perceive."

*

* *

May 14, 1904. At the end of a note on the very intense enjoyment given by Botticelli's *Spring*, I find the following observation, which raises the question of activities other than aesthetic, implied in the appreciation of form. The note deals with the very unexpected pleasure received from a picture by Angelico, which I did not know, and this, scarcely half an hour after receiving an unpleasant impression from another picture, which I knew very well, by the same master.

"It struck me at the Academy that the action of *novelty* on aesthetic impression is to set going the inquiring, discovering, prowling, *what's-what* activities on which aesthetic appreciation is carried. *Novelty makes us look because we don't know what there is.* This explains why novelty of place or represented objects acts favourably to aesthetic appreciation, while novelty of style often kills it off. The maximum appreciation is given, perhaps, by *unexpected recognition of the familiar.* We have to explore, but also to synthesise. Now in the case of the unfamiliar we can explore but not synthesise. In new friendships we are often conscious of attraction by real or fancied likeness to people for whom we have no lively feeling. On the other hand, the dead-level of old friendships is due to our having ceased to explore, and going perpetually over an old synthesis. This explains why showing a place or piece of music to another person often renovates it. We are obliged to synthesise afresh. All this proves that aesthetic pleasure has to be carried on some one of the great utilitarian processes of life. I find in a book of an American psychologist, Mark Baldwin, this phrase, which gives a phylogenetic form to this notion of mine: 'The time ... when the only function of art was that of attracting attention.'"[1]

I would add that attracting attention is now art's first necessity.

From the action of *novelty* in heightening our aesthetic responsiveness, the next extract from my diaries passes on to a cognate question: the normal alternation in aesthetic attention, and the alliance of various

competing kinds of interest to which art has recourse (interest in *subject*, e.g., with interest in *form*) in order to prevent our attention divagating by enclosing it in a rhythmical alternation.[2]

Palm Sunday. High Mass, Santa Trinità, Florence. "The great function at Santa Trinità, very beautiful to look at, with three-part music, I believe by Lotti. My hopeless state of *distrazione*: I feel that I cannot in the least keep my attention on these sights and sounds, because they are only sights and sounds. Surely this is legitimate, natural. We are not, save by exception, capable of or fit for *mono-ideism*, and what we take for it—for instance, in writing, talking, etc.—is in reality *complete synthesis*, absolute summation. Where such summation cannot, from disparity of subject, take place, there will be unsteadiness and wandering of attention; and this is our habitual condition when not engaged in doing or pursuing something continuously.[3]

"The *distraction* in the presence of, say, a work of art, is merely the surging up of the other interests of our life; it is due to the work of art not appealing sufficiently to various of our faculties while not making a sufficiently intense demand on one special group. (If, for instance, one is trying to make out a new piece of music, at the piano, with difficulty, one is usually not distracted.) There is no *distraction*, or much less, when the work of art has a *subject*, because that subject uses up our powers of associative thinking and forms a summation. If, for instance, I had had the words of the Mass, and particularly if those

words had possessed real practical emotional meaning for me, there would have been no *distraction*, simply because there would have been a blending or a synthetic rhythm, backwards and forwards, between various items; there would have been a total, a harmonious state of mind.

"What I want to point out is that division and oscillation of attention is normal in aesthetic conditions (and in most habitual ones), only that the complexity and the synthetic and regular quality of our activity makes us overlook it. At the bottom of this is of course the perpetual movement, shifting and competing in our attention, without which no consciousness would exist. It is very probable (as M. Krebs at once suggests) that we cannot think of only *one* thing at a time; we are so constituted that we must, save in most exceptional states, perpetually weave patterns between many items, come and go, fetch and carry. If the work of art gives only one sort of item, then the other items habitual in our life, worries, trifles, will compete with it. Hence the superior average power of composite art, opera, religious art, etc. etc.

"What it all comes to is that art must occupy our life, or be a mere trifle from which our life is perpetually flowing away. Again, of course much art is made for intermittent attention in the intervals of living: furniture, dress, etc.: it is, so to speak, the garment of life."

I should like my psychological reader to think over the note I have just put before him. To me it seems to represent the unexpected conclusion of many of the

observations and hypotheses given above. The notes immediately subsequent put the same question with more clearness and detail.

March 27. *Florence*. "With this hangs together the question of what I must call the *various dimensions of association*. My experience is that however attentive we are to a work of art there is always, on another plane of attention, an associated something; nay, I cannot even be in a much enjoyed landscape without distinct associations of other landscapes, not preventing my seeing that one, but in a manner continuing it in other planes of consciousness. I see this even in trifles. On a farmhouse near my home, there is a stain of sulphate of copper under the spalliered vine. I have rarely remarked it of late without a thought, sometimes a distinct vision, of Tintoretto's *Bacchus and Ariadne*, the peculiar blue of the stain being connected with the sea and sky in that picture, while the vine (even when leafless) suggests both visually and poetically Bacchus and the garland on his head and round his loins. The impression is not a fusion, still less a *confusion*; it is an oscillation between that wall (with escutcheons, stain and vine) and that picture.

"And here I may add that a great picture fulfils its purpose quite as much when thus returning to enrich an accidental impression, even if only of a stain on a wall, as when looked at in reality and for its own sake.

"I noticed this morning in Santa Trinità that whereas I could not possibly keep my attention from straying whilst sitting staring and listening to a performance

which had no intellectual or emotional sense for me, I could be absorbed therein for a few seconds of stopping on the way out.

"Our activities cannot be isolated, we must either act and feel in complete concert with what we see and hear (probably a need for synthetic action developed in self-defence, as seeing, hearing, adjusting, or escaping) or else *life claims us away from art.*

"We must not be misled (and we are) by the fact that the artist can give all his attention to the picture he is painting or the piece he is enjoying; nay the student can do so to the picture or music he is merely examining. For the artist is doing a dozen things besides merely contemplating his work; and the critic is examining, comparing, measuring, judging. Both are living a very complex life in reference to the work of art. This is the reverse of what the enjoying person is supposed to do, expecting to empty out his consciousness of everything save that seen or heard thing, and then perhaps a little bitterly surprised, almost humiliated, at not being let alone by his habitual thoughts and observations.

"*The action of art is not hypnotic, not mono-ideistic*: it is synthetic; it *excludes*, but by making a little walled garden of the soul of all manner of cognate things, a maze, in which the attention runs to and fro, goes round and round, something extremely complex and complete, taking all our faculties. This is the basis of a theory of art (this and not a theory of *Einfühlung* or anything else), this: the observed phenomenon of aesthetic attention."

Easter Sunday, 1904. "I have for years felt that the artistic phenomenon was *circular*. It seems to me now that it is perhaps our need for such circular conditions of consciousness, for such unity, attention, summation, as opposed to conflict and interruption, which accounts, quite as much as our two arms, legs and pair of eyes, for the need of symmetry. An unsymmetrical object is one which cannot *be felt* in the same manner; instead of one mood, made of coherent and interdependent impressions, we have the abortive beginnings of two moods, each struggling against the other.

"But whence this need of unity, coordination of mood? Surely it may be a necessity of the human soul in its effort to affirm itself to itself and to subdue the outer world to its purposes. The soul, consciousness, character, is forever threatened with disintegration by the various forces of nature; our surroundings tend to break us to bits, to wash us away. The human personality has purpose, direction, unity, coordination as a law of its persistence. And we persist by adapting our surroundings to ourselves quite as much as ourselves to our surroundings; indeed the latter would be on the road to disintegration, to extinction, it would mean the person, the soul, the type, swallowed up in what compared with it is the endlessly fluctuating chaos.

"Human life is a certain cycle of activities, strictly interdependent; and character is the expression, the *sine qua non* of such a cycle. Hence, in the perpetual going on, in the countless alteration to suit altering surroundings,

the necessity, for mere human self-defence, of moments of complete harmony, coordination, summation and the perpetual struggle to attain it more or less partially. The satisfaction of our bodily needs—sleep, food, generation, are not related with the persistence of the personality; they are responses of the individual to the general need. But given that the individual—what we call the soul—has come to exist as a part of the universe, this microcosm must, under penalty of destruction, perpetually seek to put its stamp upon the macrocosm, or at least affirm its existence as opposed to the macrocosm. Now the macrocosm, except as thought by us, is the external, in a manner the foreign and irrelevant, perpetually threatening us; and against it the microcosm asserts itself with its insistence on plan, unity, harmony.

"Looking at the matter from a different standpoint we might say that the line of least resistance for consciousness is the establishment of one mood at a time. Consciousness is forever trying to arrange the more or less fluctuating and incoherent items it receives into such unity, and trying to carve such unity—what we call either purpose or plan—out of the surrounding chaos.

"Art would therefore be, from the utilitarian, evolutional point of view, a school for this unity of mood, purpose and plan, without which consciousness would disintegrate and human life disappear."

1 James Mark Baldwin, *Social and Ethical Interpretations in Mental Development: A Study in Social Psychology* (New York: Macmillan Company, 1897), p. 151.

2 Titchener, *Feeling and Attention*, p. 263:

 "According to Wundt, attention is discontinuous from force of circumstances and intermittent from its very nature. It is discontinuous because ideas come and go in consciousness, and attention grasps but one idea at a time." Titchener quotes Wundt: "Ein dauernder Eindruck kann nur fest gehalten warden, indem Momente der Spannung und der Abspannung derselben mit einander Wechseln Auf diere Weise ist die Aufmerksamkeit ihren Wesen nach eine intermittirende function."

 Titchener, p. 265, quotes Ebbinghaus:

 "Dauernde Aufmerksamkeit gibt es nur bei einem stetigen Wechsel der Inhalte, in deren Hervortreten das aufmerksamsein besteht."

3 Titchener, *Feeling and Attention*, p. 302: "I doubt whether inattention, in the waking life, is not always 'attention to something else.'"

*

* *

Assisi. March 22. "Lower church. Yesterday at sunset and this morning at the Mass of the monks. (I have been recently worried and somewhat unwell.) One of the ways of coming in contact with art is, evidently, to bring one's troubles, doubts, one's fluctuating sea or ruffled puddle of distress, and live this life subdued and chastened by that of art. This is, of course, the function especially of music and architecture. Music, seeming to voice our feelings, brings them to harmony, beauty and an intensity of a higher kind."

April 23, 1904. "It is natural that a work of art should be a *Hortus inclusus*, since, when we do not *mime* the represented action and then depart, our activity of perception consists in looking round and round, in and out and back again—and looking over and over again. Hence the sense of eternity."

My Gallery Diaries, continued since the above entries, have covered a greater number of problems, have suggested a new crop of detail hypotheses, have become in fact fuller and fuller, but also proportionately more difficult to deal with; and I have therefore decided not to include any of them in a volume intended, after all, to familiarise students with the chief problems of psychological aesthetics, and even to introduce such aesthetics, its problems and hypotheses, to those who have approached art from other sides. I will, however, forestall on some future publication of this kind by saying that my diaries since 1904 have not invalidated, but only confirmed and enriched, the chief generalisations drawn from their predecessors. Further observations, more systematic and detailed, have shown me that, as regards myself at least, aesthetic responsiveness is an essentially active phenomenon, and one subject to every conceivable cause of fluctuation in our energy and variation in our moods, to the extent that (as a well-known art critic has confirmed to me in conversation) the judgment of pleasurable and displeasurable passed upon the same work of art may be altered and even reversed within a few days. I find, for instance, that the same pictures by Lotto, a very peculiar artistic personality, are described, in successive entries in my diaries, as having given me the greatest pleasure and as having utterly repelled me according to the bodily and mental condition in which I happened to come into the presence of the work of art; a fact which, explaining why certain categories of art and

certain artistic personalities may be more or less suited to individual beholders as well as to the same beholder in different moods, may show that, although artistic excellence is always due to qualities of harmonious tradition and of individual energy and equilibrium, there is within the limits of such excellence wherewithal to satisfy the cravings of the various types of normal mankind. Briefly, my notes subsequent to 1904 have added more detail while further confirming what is implicit in the Aesthetics of Empathy: namely, that the work of art requires for its enjoyment to be met halfway by the active collaboration of the beholder, or, I may add, the listener and the reader.

One last remark: these unpublished diaries subsequent to 1904 bear out on every point the contention of modern introspective psychology, namely, that a trained (if also a born) psychological observer is not only able, but inclined, to notice and record his own psychical conditions and their concomitants, without any appreciable diminution in their spontaneity and genuineness, at least in the case of phenomena so normal, so constant and, I may add, so rarely attaining emotional violence and mono-ideism, as the aesthetic affections show themselves in my own case.

Professor Lipps's testy criticism on "Beauty and Ugliness," to the effect that *it is impossible* to be aware of bodily sensations while absorbed (*Versunken*) in the joyful contemplation of a Doric column, therefore shrinks into mere evidence to an individual incapacity either for

self-observation or for such complex impressions as associate in other folks' minds the visual image of the Parthenon columns with the smell of sunburnt herbs on the Acropolis and the tinkle and bleating of sheep that rise from the valley below. It is quite possible that Professor Lipps's individual aesthetic contemplation at least of Doric columns may be of that absolutely unfluctuating and unmixed type which, in the case of very acute and massive emotion and of intensive intellectual preoccupation, defies all knowledge of its own concomitants; nay characteristics. But such impassioned or Archimedianly concentrated contemplation is, I will venture to say, by no means inevitable in our daily and loving commerce with beautiful things. And l can assure those of my friends who hesitate before aesthetic introspection as before some sacrilegious or abnormal practice, that if they are capable of the attention and self-discipline which such introspection involves, they need not be afraid of diminishing their aesthetic sensitiveness and pleasure, nor of approaching the great things of art with less of that active participation on which we are taught by empirical aesthetics that our genuine happiness in beauty essentially depends.

March 1911

Under the pseudonym VERNON LEE, Violet Paget (1856–1935) published a bewildering variety of work, including historical studies; meditative essays on art, music, gardens, and travel; philosophical dialogues; treatises on aesthetic theory and psychology; and supernatural tales. Born to a cosmopolitan English family, she settled in Florence, where she maintained friendships with artists and intellectuals throughout the world, including John Singer Sargent, Mary Cassatt, Edith Wharton, J. A. Symonds, Walter Pater, Charlotte Perkins Gilman, and G. B. Shaw. In close collaboration with her partner, the artist Kit Anstruther-Thomson, she was one of the first English thinkers to seriously engage with German empathy theory. Together, they tried to capture the mysterious and complex workings of art on our bodies, our minds, and our social lives; one of the fruits of this investigation was the 1912 volume *Beauty and Ugliness*, which included and analyzed long excerpts from Lee's own "Gallery Diaries." Partially as a result of her strong pacifist politics and opposition to World War I, Lee became somewhat estranged from the literary establishment, although she continued to write prolifically until her death.

DYLAN KENNY is a writer and PhD student in classics at the University of California, Berkeley. He coedited the exhibition catalogue *Jason Rhoades: PeaRoeFoam* (David Zwirner Books, 2015.)

JEFF NAGY is a translator, critic, and historian of technology based in Palo Alto, California. His research focuses on networks pre- and post-Internet and the development of digital labor.

"Ekphrasis" is traditionally defined as the literary representation of a work of visual art. One of the oldest forms of writing, it originated in ancient Greece, where it referred to the practice and skill of presenting artworks through vivid, highly detailed accounts. Today, "ekphrasis" is more openly interpreted as one art form, whether it be writing, visual art, music, or film, that is used to define and describe another art form, in order to bring to an audience the experiential and visceral impact of the subject.

The *ekphrasis* series from David Zwirner Books is dedicated to publishing rare, out-of-print, and newly commissioned texts as accessible paperback volumes. It is part of David Zwirner Books's ongoing effort to publish new and surprising pieces of writing on visual culture.

The Psychology of an Art Writer
Vernon Lee

Translated from the French
"Psychologie d'un écrivain sur l'art
(observation personelle)"

Published by
David Zwirner Books
520 West 20th Street, 2nd Floor
New York, New York 10011
+ 1 212 727 2070
davidzwirnerbooks.com

Editor: Lucas Zwirner
Translator: Jeff Nagy
Copyeditor: Clare Fentress
Project assistant: Mary Huber
Proofreader: Clare Fentress
Design: Michael Dyer / Remake
Production manager: Jules Thomson
Printing: VeronaLibri, Verona

Typeface: Arnhem
Paper: Holmen Book Cream, 80 gsm

Publication © 2018
David Zwirner Books
First published 2018. Second
printing 2024

Introduction © 2018 Dylan Kenny

Translation © 2018 Jeff Nagy

ISBN 978-1-941701-78-2

Library of Congress
Control Number: 2017960020

Printed in Italy